THEATRE SYMPOSIUM

A PUBLICATION OF THE SOUTHEASTERN THEATRE CONFERENCE

T5-CCX-736

Theatre and Embodiment

Volume 27

Published by the

Southeastern Theatre Conference and

The University of Alabama Press

THEATRE SYMPOSIUM is published annually by the Southeastern Theatre Conference, Inc. (SETC), and by the University of Alabama Press. SETC nonstudent members receive the journal as a part of their membership under rules determined by SETC. For information on membership, write to SETC, 1175 Revolution Mill Drive, Studio 14, Greensboro, NC 27405. All other inquiries regarding subscriptions, circulation, purchase of individual copies, and requests to reprint materials should be addressed to the University of Alabama Press, Box 870380, Tuscaloosa, AL 35487–0380.

THEATRE SYMPOSIUM publishes works of scholarship resulting from a single-topic meeting held on a southeastern university campus each spring. A call for papers to be presented at that meeting is widely publicized each autumn for the following spring. Information about the next symposium is available from Sarah McCarroll, Georgia Southern University, Department of Communication Arts, Box 8091, Statesboro, GA 30460, smccarroll@georgiasouthern.edu.

THEATRE SYMPOSIUM
A PUBLICATION OF THE SOUTHEASTERN THEATRE CONFERENCE

Volume 27 *Contents* **2019**

Introduction

Sarah McCarroll

THEATRE IS INESCAPABLY about bodies. By definition, the form requires the live bodies of performers in the same space and at the same time as the live bodies of an audience. And yet, it's hard to talk about bodies. We talk about characters, we talk about actors, we talk about costume and movement, but we often approach these as identities or processes layered onto bodies, rather than as inescapably entwined with them. It's hard to talk about bodies. Although they are capable of great grace and beauty, they also do awkward, funny, grotesque, *physical* things. And recent scholarship in both the sciences and the humanities notwithstanding, the Cartesian separation of mind-body is a deeply engrained concept: "I think therefore I am," where identity, being, one's very existence are located in the process of thinking via a disembodied intellect.

The opposite of "I think therefore I am" is "I do not think, therefore I am not," and there has been a historical tendency to elide the body as an unthinking *not*. This decentralization of the body has important consequences, however, in that it reduces the body to an object, some*thing* that is not involved in the processes that make up our existence, create our humanity. Further, an object is available—for possession, for conquest, as a blank page subject to authorship by another. This is obviously a matter of urgent importance in the world at large, but it is also the subject of growing concern and attention in the theatrical world. What stories are bodies onstage telling, both as they relate to the given circumstances of text and character, and separately from those constructs? How is meaning made onstage simply and profoundly via the presence of the human form? What does it do, for example, to the American conversation to have the musical *Hamilton* present black, Asian, and Hispanic bodies in the space occupied by the founding fathers?[1]

Bodies on the theatrical stage are liminal; therein resides their great power. They hold the power of transformation, of being always both/and. They have the potential to become other, while at the same time they are also always what they are, the body of the actor: African American actor Daveed Diggs both/and the Marquis de Lafayette and Thomas Jefferson in *Hamilton,* to continue the example. This is both the exciting possibility contained within theatre, as it makes the unimagined/unimaginable real for a time, and the thing that we as theatre practitioners, scholars, and educators must trouble as we think about what bodies go where onstage, what stories we allow which bodies to tell, and how those bodies help to create the meanings of stories on stage.

Many of the essays in this volume touch on ideas of labor, whether explicitly or implicitly. We talk about the work bodies do, where "work" is a critical term of art, but there is a sense in which bodies become fully realized in the moment that they engage in literal work of one kind or another. If bodies are about work, then they are also about economics, class, race, and gender and sexuality (among other attributes), and which jobs classed, racialized, gendered, et al. bodies can take on. This has particular resonance for us in the theatre as we think about creating spaces/theatres in which women, people of color, those without incomes, or people on a broad scope of gender and sexual identities or physical abilities can attend the theatre, or work in positions of power and decision making.[2] It also, of course, has application to questions of what bodies can do what work onstage, both within and separate from, the given circumstances of a particular text. What bodies are we willing to put in what roles? A black Hamlet? A female King Lear? A size-22 actress as Juliet, or a paraplegic Beatrice? How might our inclusion of such "nontraditional" bodies blow open the doors of meaning for texts we thought we thoroughly understood? How, too, are we structuring the repertoire to provide roles intended for, not just cast with, a multiplicity of bodies?

Theatre Symposium is largely sent to bodies that are part of the academy, engaged in education in one way or another, and so while I believe that the questions I've posed in this introduction are key to ethical educational theatre, I'd like to pose a further set of questions to readers of this journal that may be even more imperative to address: How do we, as educators, deliver expertise and agency to the bodies we work with, both our students and our colleagues? Do we create spaces in which bodies at work in the process of creating a production or learning in the classroom can expand to fill the room? Are we allowing bodies to perform authentic embodiment of their own experiences, rather than shaping them to fit handed-down, systemically embedded molds?

It's hard to talk about bodies, but it is essential to contemporary the-

atrical scholarship and practice that we do so in deep and nuanced ways. As Rhonda Blair says in her keynote essay, we must revel "in the complex and contradictory aspects of our objects of study." Our complex individual bodies unavoidably shape our perspectives as we examine the theatrical world; some of the essays in this collection make that explicit, as scholar-practitioners expand their embodied experience into theoretical or reflectively critical space. For others, that connection is implicit, as authors imagine or interrogate productions in which the performing body conforms to or opposes the bodily experience of the author in time, race, place, or gender, et al.

The essays contained here explore a broad range of issues related to embodiment. The volume begins with Rhonda Blair's keynote essay, in which she provides an overview of the current cognitive science underpinning our understanding of what it means to be "embodied," to talk about "embodiment." She also provides a set of goals and cautions for theatre artists engaging with the available science on embodiment, while issuing a call for the absolute necessity for that engagement, given the primacy of the body to the theatrical act.

The following three essays provide examinations of historical bodies in performance. Timothy Pyles works to shift the common textual focus of Racinian scholarship to a more embodied understanding through his examination of the performances of the young female students of the Saint-Cyr academy in two of Racine's biblical plays. Shifting forward in time by three centuries, Travis Stern's exploration of the auratic celebrity of baseball player Mike Kelly uncovers the ways in which bodies may retain the ghosts of their former selves long after physical ability and wealth are gone. Lawrence D. Smith's investigation of actress Manda Björling's performances in *Miss Julie* provides a model for how cognitive science, in this case theories of cognitive blending, can be integrated with archival theatrical research and scholarship.

From scholarship grounded in analysis of historical bodies and embodiments, the volume shifts to pedagogical concerns. Kaja Amado Dunn's essay on the ways in which careless selection of working texts can inflict embodied harm on students of color issues an imperative call for careful and *intentional* classroom practice in theatre training programs. Cohen Ambrose's theorization of pedagogical cognitive ecologies, in which subjects usually taught disparately (acting, theatre history, costume design, for example) could be approached collaboratively and through embodiment, speaks to ways in which this call might be answered.

Tessa W. Carr's essay on *The Integration of Tuskegee High School* brings together ideas of historical bodies and embodiment in the academic theatrical context through an examination of the process of creating a docu-

mentary theatre production. The final piece in the volume, Bridget Sundin's exchange with the ghost of Marlene Dietrich, is an imaginative exploration of how it is possible to open the archive, to create new spaces for performance scholarship, via an interaction with the body.

Given the focus of this volume, I would be remiss if I did not thank the many bodies without whose help neither the physical event nor the published volume of *Theatre Symposium* would be possible. I must first thank Dr. Rhonda Blair for making her way to Atlanta for the weekend, and for both her keynote address (the first chapter of this volume) and her insightful response to the symposium. She helped to fuel a nuanced and wide-ranging conversation over the course of our three days. In addition, while it is not possible to include every paper presented during the symposium, every attendee and presenter is due thanks for their contributions to the stimulating conversations of the weekend.

Continued thanks are due to the administration, faculty, and staff of Agnes Scott College, who allow Theatre Symposium to utilize their facilities and to enjoy their lovely campus. In particular, I must offer my ongoing gratitude to David S. Thompson, the Annie Louise Harrison Waterman Professor of Theatre at Agnes Scott, past editor of *Theatre Symposium*, and our host for the April event. He makes the logistics for the event run amazingly smoothly, and his mentorship has been instrumental in my own editorship of *Theatre Symposium*. I am also grateful to Leah Owenby, who can be counted on to have the answer to any strange question and the right power cord for any occasion; and to Pete Miller, director of Dining Services, who along with his marvelous staff sees to it that bodies are as well fed as minds. Additionally, Theatre Symposium would not be possible either as a meeting or a published journal without the support of SETC. Executive Director Betsey Horth and the central office staff, including Jean Wentz, do much to lighten an editor's load.

The topic for this edition of *Theatre Symposium* began to take shape in April 2017 during the final conversation of the Theatre and Costume conference, at which it became clear that the next logical step, having explored the topic of stage clothing, was to examine the bodies that wear those clothes. In shaping the call for papers that resulted, I have been helped by those past editors of *Theatre Symposium* who offer unstinting advice, support, and encouragement: Becky Becker, J. K. Curry, Philip G. Hill, Scott Phillips, David S. Thompson, and E. Bert Wallace. Thanks for help in producing this volume are also due to the *Theatre Symposium* editorial board, whose insights, comments, and questions have helped to shape the essays here and the volume as a whole; it would be easy for the part their bodies play in this process to become invisible, but they are an integral part of the conversation. Dan Waterman, Joanna Jacobs,

and Eric Schramm at the University of Alabama Press make the editing and proofreading process disarmingly easy, and I deeply appreciate their clarity throughout the experience.

I must also thank associate editor Andrew Gibb for two years of a grand partnership, and support both intellectual and practical. He offers unfailing encouragement, and it is worth noting in the context of this volume the very quiet work he does to create an equality of bodies. How many of your colleagues always refer to you in professional settings with your academic honorific? We are all always "Doctor" or "Professor" to Andy in those moments, which serves as a gentle acknowledgment of the agency and authority of each of us. In addition, Andy has gifted me with one of the few nicknames I've ever had, and I'm very proud to claim "Sarah Fierce" as one of my titles.

Finally, I would be remiss if I did not thank the administration at Georgia Southern University, especially Dr. Pamela Bourland-Davis, chair of the Department of Communication Arts, and Dr. Curtis Ricker, dean of the College of Arts and Humanities. They found a way to offer me course release time, making it possible for me to accept this term as editor while maintaining my responsibilities in the classroom and as resident designer and costume shop manager for the Theatre and Performance Program. In addition, my attendance at this symposium was supported by a faculty service grant. My colleagues in Theatre and Performance, Lisa Abbott, Kelly Berry, Nicholas Newell, and Katie Rasor, also offer essential support. I must end with personal thanks to my mother, Dr. Roberta Rankin, whose own work as a certified teacher of Alexander Technique, as well as her career as a professor and director, has been instrumental to the development of my own ideas of embodiment; she is a source of unwavering support in all areas of my life.

Notes

1. For a discussion of this issue, see Lin-Manuel Miranda, interview by Jeffrey Brown, *PBS NewsHour*, November 20, 2015, https://www.youtube.com /watch?v=HAiEVjW-GNA.

2. The Wellesley Centers for Women's 2016 Report on "Women's Leadership in Resident Theatres," for example, found that of seventy-four LORT Regional Theatres surveyed in 2013–2014, the gender and racial breakdown of artistic directors was fifty-four white men, five men of color, fourteen white women, and one woman of color. The breakdown of executive directors for the same theatres was forty-six white men, twenty-eight white women, and no men or women of color. The survey further found that in those theatres, the next in line for leadership patterns continued this theme, although showing a somewhat more balanced gender breakdown. The next in line for artistic leadership breakdown was

thirty-one white men, three men of color, twenty-one white women (two un-
determined), and five women of color; the next in line for executive leadership
breakdown was twenty-five white men (one undetermined), two men of color,
fifty-five white women (two undetermined), and five women of color. Obviously,
this report examines only two elements of diversity; I call attention to it as an
example rather than as a comprehensive examination. Sumru Erkut and Ineke
Ceder, *Women's Leadership in Resident Theatres: Research Results and Recom-
mendations Executive Summary* (Wellesley, MA: Wellesley College, Wellesley Cen-
ters for Women, 2016), 1, accessed July 17, 2018. https://www.wcwonline.org
/Active-Projects/womens-leadership-in-resident-theaters.

Theatre and Embodiment

Rhonda Blair

T HE CALL FOR PAPERS for this symposium stated, "At the heart
of the theatrical act is the simultaneous live presence of the ac-
tor and the audience. Given the primacy of the theatrical act, how do
we understand those bodies as communicating meaning?" For the past
two decades, research in cognitive science and neurosciences has been my
way into this topic. This essay gives an overview of some aspects of the
science and describes how they can help us understand the operations of
bodies in theatre and performance, and also make us more articulate and
effective artists and scholars.

The science isn't fixed and stable; new findings build on preceding
theories and discoveries. There isn't a single methodology—though there
is general agreement that Descartes's mind-body split was wrong, and
that emotions and the body are essential to, not distractions from, cog-
nition. There is a broad array of applications; while some theatre people
do scientifically structured research, most of us use the science to illu-
minate the particular performance problem or theory we're working on.
Further, it is useful when various fields in science, arts, and humanities
engage with each other, particularly when they're exploring the same
questions (for instance, psychologists, cognitive scientists, cognitive lin-
guists, literary scholars, and theatre artists are all interested in how lan-
guage works). Using the science isn't necessarily essentializing; rather, the
study of how bodies, brains, and cognition work in humans as a species
provides a common ground, based on material evidence, for moving on to
examine how these manifest in different historical and cultural contexts.
In fact, if cognition is embodied, embedded, extended, and enacted—as
4E (see the "4E" Cognition section later in this chapter) and situated

approaches to cognition assert—cognitive systems are in fact inseparable from cultural systems.

Some Recent Cognitive Science(s)

Particularly pertinent is neuroscientist Antonio Damasio's assertion that reason in the fullest sense grows out of and is permeated by emotion, that emotion is consistently affected by reason and conscious cognition, and that it all is a manifestation of the body (of which the brain is an organ). The brain is a definable organ, but mind is "a process, not a thing."[1] Further, mind is not the same thing as consciousness, since most of the crucial functions of mind (such as homeostatic regulation, proprioception, and kinesthetic response) occur un- and subconsciously. That is, unconscious mind is much more than what is defined in the Freudian or psychoanalytic sense, since as much as 98 percent of the brain's functioning is "outside of conscious awareness."[2] The "self," insofar as it is something we experience, is dynamic and fluid, a neurophysiological process that rises to awareness only as a small part of a large organic event; as neuroscientist Joseph LeDoux says, the self is "not real, though it does exist."[3] From this perspective, our sense of self is a process that arises from the workings of our synapses, the gaps between neurons bridged by chemicals or an electrical impulse; thus, nature (genetic makeup) and nurture (experiences) are different ways of doing the same thing—wiring synapses in the brain that ultimately manifest as "who we are." Damasio's somatic marker hypothesis describes how body-states become linked with conscious responses to or interpretations of them[4] (i.e., body, feeling, and intellect are aspects of a single, complex organic process). Crucially, Damasio asserts that reason in the fullest sense grows out of and is permeated by emotion (for neuroscientists, a preconscious neurophysiological body-state), and that these body-states are conditioned by reason and conscious cognition.

The level of the explicit or autobiographical self is the one at which we basically tell ourselves stories about who we are; it is how we *imagine* our experience in order to ascribe meanings to it. Thus, while we cannot directly control how our brains get "wired," we can examine how interpretations of experience—basically, how we imagine our experience—affect these constructed senses of self and our situations. Our conscious sense of self is necessarily fictional to some, even to a large degree, for it is composed of stories we create to help make sense of our experience and to be able to function socially.[5] Damasio's somatic marker hypothesis, which describes how the sense of a self rises to the level of consciousness, holds that the brain creates strings of associations arising in the body,

first as an emotion (body-state), which rises to the level of feeling, that is, a more or less conscious "registering" of an emotional state: "something's happening." This then leads to behavior, which is a response to all of the preceding that may or may not be associated with reason or rational thought, since behavior often precedes awareness and direct feeling (e.g., we can reach for a cup or a pen without consciously deciding to do so). Over time body-states become "marked," as they become neurally and kinesthetically linked with conscious responses to and interpretations of body-states. For instance, we see a tiger and can interpret the adrenaline rush that occurs as fear or excitement, even though the physiological response to the event is the same. These linking mechanisms reduce the range of behavioral choices we need to make, allowing us to respond spontaneously and quickly to the environment, thereby increasing our chances for survival. This evolutionarily necessary trait of habituation can have a theatrical downside, as it might limit performers in being present in an immediate way to a rehearsal and performance experience if they are locked into habituated responses to given situations that are counterproductive to the work at hand; sensory and kinesthetically oriented exercises can be a way of de-habituating and expanding the performer's range.

Damasio's hypothesis resonates with Stanislavsky's holistic way of thinking about the actor. For Damasio, "the apparent self emerges as the feeling of a feeling."[6] Consciousness begins with a preconscious narrative—a "sub-consciousness" imagining of a "story"—that arises as the organism begins to be aware of and then registers the feeling of the neural and chemical events of the body, which are then used to define itself—a self—in relationship to objects and events. Consciousness, as a process of the body, makes it possible for the organism to negotiate its way through its environment, through the given circumstances of its life. Damasio also addresses imagination in a way that can be connected to Stanislavsky's "if." He describes imagination's organic source and pragmatic function in evolutionary brain development; he links homeostasis (i.e., basic biological balance and maintenance of the organism) to imagination, in that the organism envisions possible responses to a given situation to allow it to maximize possibilities for homeostasis or, at the least, survival. This autonomic drive for homeostasis is thus fundamental to the biology of consciousness, and imagination is fundamental to our *physical* selves, not just our psyches. This provides a material foundation for the validity of much of Stanislavsky's psychotechnique; actors get at imagination by engaging the senses—visual, aural, olfactory, and kinesthetic. That is, we get at imagination and attention through the body.

Emotions, feelings, thoughts, and behavior become linked over time

through associative learning, and any one aspect can lead the process at any given moment (i.e., an experiential sequence can be initiated by body-state, thought, or gesture). Further, there is measurable neurological evidence that emotion and feeling can follow "doing." As Damasio says, "In the beginning was emotion, but at the beginning of emotion was action."[7] This statement points toward the work in embodied cognition of philosopher Alva Noë, who has written extensively about the relationship between action and perception. More immediately, the research provides material evidence for the efficacy of some aspects of Stanislavsky's methods of physical action and of active analysis, Meyerhold's biomechanics, Michael Chekhov's psychological gesture, Strasberg's sense memory exercises, Meisner's repetition exercise, and Tadashi Suzuki's intense psychophysical training, among others.

Roughly a quarter-century ago, psychologists and philosophers began articulating a way of viewing our selves as functioning and growing through dynamic interactions with the environment. Edwin Hutchins laid out a basic view of cognition "in the wild"—"human cognition in its natural habitat"—as "a naturally occurring culturally constituted human activity," a fundamentally "cultural and social process": "Human beings are adaptive systems continually producing and exploiting a rich world of cultural structure. . . . This heavy interaction of internal and external structure suggests that the boundary between inside and outside, or between individual and context, should be softened. . . . The proper unit of analysis for talking about cognitive change includes the sociomaterial environment of thinking. *Learning is adaptive reorganization in a complex system.*"[8]

Philosopher Evan Thompson says our world "is not a prespecified, external realm, represented internally by its brain, but *a relational domain enacted or brought forth by that being's . . . mode of coupling with the environment.*" The relationship between the organism and the world is one of "*dynamic co-emergence*" (i.e., "*cognition unfolds as the continuous co-evolution of acting, perceiving, imagining, feeling, and thinking*").[9] The organism engages in *autopoesis*, or self-making, within an *ecopoetic* situation; the self is not made without being made by and also making its environment. Mind is "an embodied dynamic system in the world," not a "neural network in the head."[10]

As psychologist William Clancy writes, "We cannot locate meaning in the text, life in the cell, the person in the body, knowledge in the brain, a memory in a neuron. Rather, these are all active, dynamic processes, existing only in interactive behaviors of cultural, social, biological, and physical environment systems."[11] Keith Sawyer and James Greeno, writing about cognition and learning, say that the learning environment is

an unstable structure that "is dynamically co-constructed by the problem solver in collaboration with material resources, sources of information, and (very often) other people in the situation";[12] this description could be used for many, if not most, environments, including rehearsals and performance. Their description of the learning environment as a "problem space" explicitly echoes Stanislavsky's term *zadacha*, Russian for "problem" or "task" (*not* "objective"!)—a core term for what the character is trying to accomplish or solve within her given circumstances, or environment. All these involve the body imagining itself in relationship to the situation at hand.

I don't do fieldwork in the cognitive wild of "regular life" more broadly, but I use the science to devise multi-modal practices for theatre-making and pedagogy. I don't "do" science; I use it. The cognitive sciences support what theatre practitioners intuitively know: we are holistic beings, inextricable from our environment, which includes each other. We function within cognitive ecologies, and each theatre event is its own cognitive ecology: "Cognitive ecologies are the multidimensional contexts in which we remember, feel, think, sense, communicate, imagine, and act, often collaboratively, on the fly, and in rich ongoing interaction with our environments. . . . The idea is not that the isolated, unsullied individual first provides us with the gold standard for a cognitive agent, and that mind is then projected outward into the ecological system: but that from the start (historically and developmentally) remembering, attending, intending, and acting are distributed, co-constructed, system-level activities."[13]

"4E" Cognition

Aspects of our cognitive ecologies are made up of the 4Es, which posit that cognitive functions operate in the entire individual and her environment; in other words, cognition is:

Embodied—cognition isn't separable from our physical being. It depends on the body as well as the brain.
Embedded—cognition depends heavily on off-loading cognitive work and exploiting potentials, or affordances, in the environment and is therefore a result of "ongoing agent-environment interaction."
Extended—cognition extends beyond the boundaries of the individual, encompassing aspects of our social, interpersonal environment: "the mind leaks out into the world and cognitive activity is distributed across individuals and situations."[14]
Enacted—cognition is inseparable from action and is often an outgrowth or even an attribute of action.[15]

In short, "Without the cooperation of the body, there can be no sensory inputs from the environment and no motor outputs from the agent—hence, no sensing or acting. And without sensing and acting to ground it, thought is empty."[16]

There are links between sensorimotor and semantic understanding, links between body/action and language: language production, language comprehension, and perception of intent are neurally inseparable; some of the same areas in our brains are crucial to language production *and* to language comprehension *and* to perceiving the intention of physical actions such as grasping and manipulation.[17] Some scientists hypothesize that language may have evolved from a neurally grounded, preconscious perception of gestural intention. Research shows that "the *sensorimotor* cortices are crucial to *semantic* understanding" of action. That is, "body" parts of the brain are necessary for linguistic understanding. This is a two-way street; whether you pick up a box or someone tells you to "pick up that box," many of the same neurons are activated.[18]

There are cognitive links and flows between us and others: the ecology in which we live and to which we react includes other people. This engages things such as neural and kinesthetic mirroring systems and mind reading; aspects of cognition are interrelational and involve "theory of other minds," or TOM: we respond based on our ability to read the intentions of others, both consciously and preconsciously. This is about perceiving not just the action of an other, but the *intention* of the action (a *part* of this is connected to mirror neurons, which "respond strongest to the *goal of the action*, not to the action itself" when we see someone act).[19] A provocative hypothesis related to TOM is that "'I' may have begun with 'you'": TOM—our sense of others, of being in dynamic relationship to them—may have arisen *before* we had the sense of a self. Neuroscientist V. S. Ramachandran hypothesizes that TOM "evolved *first* in response to social needs and then later, as an unexpected bonus, came the ability to introspect on your own thoughts and intentions."[20]

The body's capacities and actions determine and constrain what we perceive: Noë states that perception "is something we do. . . . *What we perceive* is determined by *what we do* (or what we know how to do); it is determined by what we are *ready* to do. . . . We *enact* our perceptual experience; we act it out." That is, there is no perception without action: "Perception is not something that happens to us, or in us. It is something we do. . . . The world makes itself available to the perceiver through physical movement and interaction."[21] This shifts what it means to be in space and time, for action occurs in space and time, and in relationship to others in that space. Philosopher Shaun Gallagher holds that space is

first of all about our activities within it; spatiality isn't about position, but about *situation*,[22] constrained by the particular possibilities of our bodies, which are "primarily designed for *action. . . . The brain attunes itself to what the body and the environment affords.*"[23]

Taking action "*can be a form of representing.*" In this view, to have a representation is to act. As Alva Noë pointedly asks, if a person is *in* the world, why does she need to produce "internal representations good enough to enable [her], so to speak, to act as if the world were not immediately present?" No "'translation' or transfer is necessary because it is already accomplished in the embodied perception itself."[24] Or perhaps "to visualize is to do, and to do is to visualize." This linkage of perception and action leads to a provocatively useful troubling of the idea of representation. In situated cognition, representation can refer to mental images, references, and neuronal firing patterns, among other things.[25] In previous generations of cognitive science, it was assumed that external elements in our world are represented in our brains. That's certainly what it seems like: thinking of an apple seems to generate a mental representation of an apple. This does not mean, however, that there is a place where all things apple reside in our brain. What apple are you picturing? From what angle? Is it partially eaten? It is true that the visual system is activated when we think of an apple—which accounts for the fact that we can see an apple in our "mind's eye" when we think of "apple"—but the apple imagined is specific to the context and it relies on the same system of neurons that sees an apple with the actual eye. In Noë's understanding, representation is neither abstracted nor independent from the perceptual system.

In this framework, *the image doesn't represent meaning*; rather, it prompts meaning-making.[26] The image points toward possibilities for action; these are physically linked in our brains: "*imagining and doing use a shared neural substrate,*" and also "*the same neural substrate used in imagining is used in understanding.*"[27] This is crucial for theatre, because action is the heart of the art. The images are not end points, but tools for creativity.

When working with actors, I sometimes ask them to eliminate the "phase" of mental representation to set up (or "motivate") action: let doing lead the representation or "meaning." Or—let the environment itself be the "representation," the focus. (This can be seen as related to Declan Donnellan's writing in *The Actor and the Target*[28]—connect the actor to what's in front of her in the moment, in its context.)

Just because our language separates doing and thinking and feeling and sensing does not mean that's what is going on. Just because those are

sometimes the categories of our processing does not mean they're useful in making sense of what and where cognition is. This is important because it gets to the very core of who we think we are—not just as performers or spectators, but as human beings. We think with and through our moving, perceiving bodies. Just as we use our visual system to process "apple," we use our motor cortex for action understanding. The degree to which humans have mirror neurons may still be under investigation, but the fact of motor resonances is clear. When we witness an actor make an intentional action—grab the gun, cock her fist, lean forward to kiss his son—neurons fire in us that also fire when we do that action; a subset of neurons involved in the action also fire in perception. When we read a sentence about an action, it will activate some of the same neurons in the brain required to do the action; to understand a sentence such as "he turned down the volume," we recruit some of the same motor neurons responsible for making the knob rotation action with the hand, even though it is the intention described in the sentence, not the action needed to accomplish the goal. According to Zwaan, "Motor processes are not merely output processes but are a central part of cognition."[29]

Paradigms of action are increasingly superseding paradigms of (mental) representation, since cognitive processes are hybrid, straddling "both internal and external forms of information processing."[30] The primed muscles in the hand, ready to turn down the volume, are involved in "representing" our comprehension of the sentence. Most radically, philosopher Anthony Chemero says that it's all pretty much action and perception, with no need for representation at all.[31]

Cognitive Linguistics

A crucial area for our theatre work is language and linguistics. Language is embodied, a component of both action and representation; as Fauconnier and Turner note, "*Language does not represent meaning directly; instead, it systematically prompts the construction of meaning.*"[32] *The state of the body is not only an input into language interpretation, it is also an output.* As Amy Cook writes, it could be "that language is less a system of *communicating* experience than actually *being* experience; we do not translate words into perceptions, we perceive in order to understand."[33] In this view, in theatre—as in life—body, breath, voice, language, imagination, and environment are inseparable. All of the preceding echoes Stanislavsky's concept of the characters in given circumstances: bodies in shared environments, trying to accomplish actions.

Sometimes a fifth "E" is included in this work. Empathy is at the heart of theatre and performance, and it is in fact a generic term applied

to a whole array of neural, cognitive, and kinesthetic responses that are evoked in us by an other, who can be real or *imagined*. In order to connect with the other person, we need empathy. In order to understand what the other person is saying or doing, we need empathy—as artists, coaches, teachers. Empathy has three attributes: First, you must to some degree be feeling what the other person is feeling; second, you must to some degree be able to visualize or imagine yourself in the other person's situation; and, third, you need to know that you are *not* in fact the other person.[34] We relate to and copy each other on a number of levels, while remaining aware that we are not the other and can behave differently from the other.[35] (What rich territory for someone who thinks about acting!)

So, in terms of studio/rehearsal applications and working with text and history, this means my default questions are: "How can I make this physical?" "What is going on with relationship and environment?" "How can I describe or activate this in terms of experiences the artist has had (metaphor, analogy, metonymy)?" "How can the actor or designer connect this to something sensory?" "How can I use personal relationships and our actual physical environment to bring the material to life?" Situated, 4E, and enactivist approaches are de facto social *and* political, as well as personal. The default mode is "embodied, embedded, extended, and enactive": how can we use our bodies, our environments, our imaginations, and our connections to each other to engage material, whatever it is, in an enlivened, even urgent way that will make us clearer and more attuned to it—and the world?

Goals and Caveats

This work adds to our understanding of what it means not just to have but to *be* a body, engaging imagination, emotion, constructions of self, interrelationships, memory, and consciousness, among other things. Current cognitive science dislocates a number of things, among them familiar constructs of identity, feeling, and selfhood that have been dominant for decades, and any belief that culture and biology are separable. At the same time, we must be cautious about our applications—even appropriations—of the science and honest about our motives for doing so. Cognitive science is not a monolith. Not everyone agrees and even those who are persuaded by the arguments understand that good science is always awaiting falsification. However, provisional does not mean untrue; gravity is a provisional theory and yet we don't need to walk off a building to believe it.

Science has long informed our engagement with theatre and performance, but there are limits to the relationship and caveats about applica-

tions. Scientists use a reductive approach—verification through repeatable experimentation that accounts for all the variables involved in the experiment; the process is inductive. In the arts and humanities, theorizing (or, more accurately in science's vocabulary, hypothesizing) is typically deductive, based upon the examination of texts and historical artifacts, the observation of performances, or the assessment of the experiential through a particular critical, philosophical, or political framework, which often involves a good degree of subjective interpretation. The inductive nature of science demands that it be reductive, looking at specific, even microscopic objects such as a single neuron in the brain. Underpinning the sciences are principles of falsifiability and repeatability. Theories and things presented by science as facts are proven by results that are repeatable, experiment after experiment, and that are always subject to being disproved when a new experiment produces different results; science is highly contingent and involves its own kinds of subjective assessments of evidence. This is, of course, foreign to performance studies' reveling in the complex and contradictory aspects of our objects of study. Interestingly, when scientists bring together the results of a broad range of experiments to reach general conclusions, this brings more variables into play across the experiments and often makes conclusions more speculative (i.e., the broader the assertion, the further scientists move into conjecture and hypothesis and away from science). For this reason, among others, those of us in performance and theatre studies must engage primary and secondary scientific research, educating ourselves in the terrain of these sciences and the standards by which they operate. Summary articles in recognized journals are useful points of entry because they provide a context for and condensation of research on particular topics, including competing arguments and claims; we must engage, or at the very least acknowledge, these competing claims if we are to have a hope of being responsible in our appropriations and applications.

Among the things those of us working with this material have been learning: we have to be cautious in using research on the neural level to explain anything in the realm of the experiential or conscious; the discovery of mirror neurons in monkeys, for instance, did not immediately mean that humans had mirror neurons or that they functioned identically in us, or that the discovery of neural simulation in humans meant that we are intrinsically empathetic. We have to be clear about what is scientific theory (i.e., an explanation that accounts for observable phenomena), following processes of repeatability and falsifiability, and what is hypothetical (i.e., *possible* explanations for phenomena which have not yet been borne out by experimentation). It is important to discern between data and conjecture. We have to be sensitive to contradictions and

disagreements among the scientists' explanations of what they have discovered by experimentation and how they are interpreting it. We have to be clear about the differences among the various cognitive science disciplines in terms of methodology and parameters for truth claims—there are differences in the processes and perspectives of cognitive linguists and neuroscientists. We have to be respectful of the power—conscious or otherwise—of metaphor and the intrinsic human tendency to think metaphorically and analogically. Sometimes these associational leaps are apt, and sometimes not, growing as they do out of experience, habit, and desire. Having made this last caveat and acknowledging that the use of science qua science can be profoundly important, the use of science as a springboard to engage theatre, dance, and performance can be incredibly rich—but this potential for creativity and for experiential and intellectual efficacy is different from making a claim that what we do has the efficacy or "truth" of science.

Different kinds of evidence, ranging from the neural to the linguistic and behavioral, are useful for different aspects of performance and theatre studies, but they cannot be applied whole cloth. But everything discussed here is, ultimately, about the body—what it means to *be* a body that feels and thinks in specific environments and ecologies.

Notes

Parts of this paper are derived from Rhonda Blair and John Lutterbie, "Introduction: Journal of Dramatic Theory and Criticism's Special Section on Cognitive Studies, Theatre and Performance," *Journal of Dramatic Theory and Criticism* 25, no. 2 (Spring 2011): 61–70; and introductory materials in Rhonda Blair and Amy Cook, *Theatre, Performance and Cognition: Languages, Bodies and Ecologies* (London: Methuen, 2016).

1. Antonio Damasio, *The Feeling of What Happens: Body and Emotion in the Making of Consciousness* (New York: Harcourt Brace & Company, 1999), 183.

2. Michael Gazzaniga, *The Mind's Past* (Berkeley: University of California Press, 1998), 21.

3. Joseph LeDoux, *Synaptic Self: How Our Brains Become Who We Are* (New York: Penguin Books, 2002), 31.

4. Antonio Damasio, *Descartes' Error: Emotion, Reason, and the Human Brain* (New York: Avon, 1994); Damasio, *The Feeling of What Happens*, esp. 173–80.

5. See Gazzaniga, *The Mind's Past*, 21–23; and Joseph LeDoux, J. Debiec, and H. Moss, eds., *The Self: From Soul to Brain, Annals of the New York Academy of Sciences* 1001 (New York: New York Academy of Sciences, 2003), 7–8.

6. Damasio, *The Feeling of What Happens*, 30–31.

7. Ibid., *The Feeling of What Happens*, 80.

8. Edwin Hutchins, *Cognition in the Wild* (Cambridge, MA: MIT Press, 1995), xii, xiv, 288–89; emphasis mine.

9. Evan Thompson, *Mind in Life: Biology, Phenomenology, and the Sciences of Mind* (Cambridge, MA: Belknap Press of Harvard University Press, 2007), 13, 60, 43; emphasis mine.

10. Ibid., 11.

11. William Clancy, "Scientific Antecedents of Situated Cognition," in *The Cambridge Handbook of Situated Cognition*, ed. Philip Robbins and Murat Aydede (Cambridge: Cambridge University Press, 2009), 28.

12. R. Keith Sawyer and James G. Greeno, "Situativity and Learning," in Robbins and Aydede, eds., *The Cambridge Handbook of Situated Cognition*, 349.

13. Evelyn Tribble and John Sutton, "Cognitive Ecology as a Framework for Shakespearean Studies," *Shakespeare Studies* 39 (2011): 94.

14. Philip Robbins and Murat Aydede, "A Short Primer on Situated Cognition," in Robbins and Aydede, eds., *The Cambridge Handbook of Situated Cognition*, 10.

15. Alva Noë, *Action in Perception* (Cambridge: MIT Press, 2004), 1–11 and elsewhere.

16. Robbins and Aydede, "A Short Primer," 3–4.

17. Luciano Fadiga, Laila Craighero, Maddalena Fabbri Destro, Livio Finos, Nathalie Cotillon-Williams, Andrew T. Smith, and Umberto Castiello, "Language in Shadow," *Social Neuroscience* 1, no. 2 (2006), 77–89.

18. John Kaag, "The Neurological Dynamics of the Imagination," *Phenomenology and the Cognitive Sciences* 8, no. 2 (2008), 183–204, 186, emphasis mine.

19. Lawrence Barsalou, "Grounded Cognition," *Annual Review of Psychology* 59 (2008), 623; emphasis mine.

20. V. S. Ramachandran, "The Neurology of Self-Awareness," *Edge* (November. 3, 2015), http://edge.org/conversation/the-neurology-of-self-awareness.

21. Noë, *Action in Perception*, 1–2.

22. Shaun Gallagher, "Philosophical Antecedents of Situated Cognition," in Robbins and Aydede, eds., *The Cambridge Handbook of Situated Cognition*, 41–42.

23. Shaun Gallagher, "Invasion of the Body Snatchers: How Embodied Cognition is Being Disembodied," *The Philosopher's Magazine* (April 2015): 100; emphasis mine.

24. Noë, *Action in Perception*, 130–31, 22, 80; emphasis mine.

25. Gallagher, "Philosophical Antecedents of Situated Cognition," 47.

26. Gilles Fauconnier and Mark Turner, *The Way We Think: Conceptual Blending and the Mind's Hidden Complexities* (New York: Basic Books, 2002), 142.

27. Vittorio Gallese and George Lakoff, "The Brain's Concepts: The Role of the Sensory-Motor System in Conceptual Knowledge," *Cognitive Neuropsychology* 2, nos. 3–4 (2005): 2.

28. Declan Donnellan, *The Actor and the Target* (New York: Theatre Communications Group, 2006).

29. R. A. Zwaan and L. J. Taylor, "Seeing, Acting, Understanding: Motor Resonance in Language Comprehension," *Journal of Experimental Psychology* 135, no. 1 (February 2006): 2.

30. Mark Rowlands, "Situated Representations," in Robbins and Aydede, eds., *The Cambridge Handbook of Situated Cognition*, 127.

31. Anthony Chemero, *Radical Embodied Cognitive Science* (Cambridge: MIT Press, 2009).

32. Fauconnier and Turner, *The Way We Think*, 142.

33. Amy Cook, "Interplay: The Method and Potential of a Cognitive Scientific Approach to Theatre," *Theatre Journal* 59, no. 4 (2007): 589.

34. Claus Lamm, C. Daniel Batson, Jean Decety, "The Neural Substrate of Human Empathy: Effects of Perspective-taking and Cognitive Appraisal," *Journal of Cognitive Neuroscience* 19, no. 1 (2007): 42.

35. Jean Decety and Jessica A. Sommerville, "Shared Representations between Self and Other: A Social Cognitive Neuroscience View," *TRENDS in Cognitive Sciences* 7, no. 12 (December 2003): 527.

Additional References

Batson, C. Daniel. "These Things Called Empathy: Eight Related but Distinct Phenomena." In *The Social Neuroscience of Empathy*, ed. Jean Decety and William Ickes, 3–15. Cambridge, MA: MIT Press, 2011.

Blair, Rhonda. *The Actor, Image, and Action: Acting and Cognitive Neuroscience.* New York: Routledge, 2008.

Blair, Rhonda, and Amy Cook. *Theatre, Performance and Cognition: Languages, Bodies and Ecologies.* London: Methuen, 2016.

Cook, Amy. *Shakespearean Neuroplay: Reinvigorating the Study of Dramatic Texts and Performance through Cognitive Science.* New York: Palgrave Macmillan, 2010.

Edelman, Gerald, and Giulio Tononi. *A Universe of Consciousness: How Matter Becomes Imagination.* New York: Basic Books, 2000.

Gallagher, Shaun. *How the Body Shapes the Mind.* Oxford: Oxford University Press, 2005.

Kandel, Eric R., and Larry R. Squire. "Neuroscience: Breaking Down Scientific Barriers to the Study of Brain and Mind." In *Unity of Knowledge: The Convergence of Natural and Human Science*, ed. Antonio R. Damasio, Anne Harrington, Jerome Kagan, Bruce S. McEwen, Henry Moss, and Rashid Shaikh, 118–35. New York: Academy of Sciences, 2001.

Lutterbie, John. *Toward a General Theory of Acting: Cognitive Science and Performance.* New York: Palgrave Macmillan, 2011.

Tribble, Evelyn. *Cognition in the Globe: Attention and Memory in Shakespeare's Theatre.* London: Palgrave Macmillan, 2011.

Bodies of Theology

Racine's *Esther* and *Athalie*
as Embodied Theology

Timothy Pyles

T HE 1991 PUBLICATION OF David Maskell's groundbreaking study *Racine: A Theatrical Reading* greatly contributed to the reevaluation of Racine's plays as performance texts, marking a major shift away from the previously prevalent view that Racine's plays were best understood as, essentially, closet dramas, the theatricality of which was at best incidental.[1] Nevertheless, the idea that Racine's was a theatre principally of words, of disembodied poetry, has persisted. Mitchell Greenberg has claimed that, while bodies are indispensably and inevitably a part of theatre, bodies in Racine's tragedies have, in essence, been banished; that real, corporeal bodies have been replaced by the disembodied voice, by an affective description of bodies meant to control the corporeal body by means of the discursive. As Greenberg puts it, "'Bienséance [lit. 'good sense,' the decorous style and appropriate content expected of French neo-Classical drama] . . . when coupled with those other rules of French neo-Classical protocols, the 'three unities,' can be seen as doing to the theatrical body precisely what Foucault suggested the general epistemic shift of the seventeenth century did to those suddenly socially undesirable others—the mad, the heterodox, the feminine. The body is circumscribed, limits are imposed on it (limits to its visibility), it is objectified as foreign to a certain aesthetic (but also sexual and political) ideal, and then it is banished. The body in French Classical drama is expelled from the stage."[2] Sylvaine Guyot responded to the ongoing tendency to downplay the importance of corporeal bodies in Racine's work in her 2016 article for *Modern Language Quarterly*, "Opacity of Theater: Reading Racine with and against Louis Marin," in which she positions her work as an attack on "the long critical tradition that has reduced Jean Racine's dramaturgy to the poetic effects of its language" and, instead,

as "emphasizing the crucial role played by the bodily medium in Racinian theater."[3] Guyot's article is focused on Racine's plays *Bérénice*, *Mithridate*, and *Phèdra*, and is a continuation of arguments she began in her 2014 book, *Racine et le corps tragique*, which similarly argued against disembodied readings of Racine and for a renewed emphasis on the body.[4] Maskell's work is focused on reconstructing the staging of Racine's plays as they would have appeared to an audience, and is therefore most interested in how the plays would have looked, including settings, costumes, the use of props, etc. Guyot's work focuses on the body more specifically, but does so again from the perspective of the outside interpreter—her work interrogates how the body in Racinian theatre changes and complicates a spectator's interpretation of the play.[5]

In this article it is my intent to contribute to this ongoing reevaluation of Racine's work, and specifically the reevaluation of the importance of bodies in Racine. Despite a renewed focus on Racine's plays in performance, an important gap exists in the current discussion of Racine. That gap is an exploration of the ways in which the embodiment of the plays by the actors creates meaning not only for the spectators, but also for the actors themselves. In this article I address this issue by examining Racine's two late biblical plays, *Esther* and *Athalie*.

Esther and *Athalie* provide a unique opportunity to examine embodiment in Racinian theatre. Both were written to be performed by the young female students of the school at Saint-Cyr. Saint-Cyr was a school for young women of the nobility whose families had fallen into poverty and could therefore not afford to educate their daughters. It was established by Louis XIV's second wife, Madame de Maintenon, and was located not far from Versailles. Girls began their studies at Saint-Cyr at the age of ten and continued until the age of twenty, whereupon they had the option either to marry, with a small dowry provided by the school, or to become a nun. A few students are known to have stayed on at Saint-Cyr and become teachers. During their time at Saint-Cyr, the young women were instructed in theology and doctrine, as well as in the sorts of domestic and social responsibilities that were expected of wives of the noble class. Around 300 students attended the school.[5]

Esther and *Athalie* were commissioned by Madame de Maintenon to be performed by the young women of Saint-Cyr, with the intent that they be rehearsed and performed during the winter Carnival season, as a means of occupying the girls' attention with something pious during that season of traditional revelry and disorder.[6] Further, it was Madame de Maintenon and Racine's intent that the performance of the plays would serve "pour l'édification et instruction des jeunes demoiselles confiées à leur conduite"—"for the edification and instruction of the young women entrusted with their performance."[7] And that the performance of the

plays would "inspire des sentiments tout chrétiens"—"inspire Christian sentiments"[8]—not only in the watching audience, but in the female actors themselves.

Esther premiered on January 26, 1689, to a select audience that included the king. It was an elaborate production. It involved three distinct sets, one for each act of the play, extravagant costumes, and original music. The sets were designed by Jean Bérain, who was the designer of the court spectacles performed at Versailles. The costumes were designed by Madame de Maintenon herself, and the music was composed by Jean-Baptiste Moreau, court composer to Louis. The entire production cost over 15,000 livres. It was performed indoors, in the hall of the dormitories (a large space on the second floor), so as not to disrupt the classes that were held on the first floor of the school.[9] *Athalie* premiered in the same space on January 5, 1691, also during Carnival season, to a smaller audience than *Esther*, but once again including the king. In contrast to *Esther*, however, *Athalie* was performed in the girls' regular school uniforms, with a very minimal set and with only a few simple props. Original music composed by Moreau was once again performed.[10]

The reason for the change in production values between the elaborate production of *Esther* and the simple staging of *Athalie* is not entirely clear. However, based on a few comments made in journals and private correspondences from the time, it appears most likely that the change in approach was occasioned by the unhappiness of the Mother Superior of Saint-Cyr with the expensive sets and costumes of *Esther*. The Superior, Madame Durand, is referred to in the memoires of Pierre Manseau as a "grand ennemi des spectacles"—"a great enemy of spectacles"[11]—and there are a few other extant comments noting that some members of the court who saw *Esther* thought its extravagance likely to inspire vanity in the young women who performed it.[12] This was of course precisely the opposite of the intent of Madame de Maintenon and Racine, and so, perhaps, *Athalie* was staged as humbly and simply as it was in order to emphasize that which was most important—the speaking, moving, and singing of the young women themselves, and the truths they might learn through their embodiment of Racine's text.

It is on this axis that I examine these two plays. Not knowing anything about the blocking of the actors in the original performances, and lacking any images depicting those performances, my focus is on the texts themselves. I will seek, through a close reading of these two texts, to discover and elucidate some of the specific means by which Racine sought to place moral and theological truths into the bodies of the actresses, how he embodied that which he wished to teach the young women of Saint-Cyr.

Racine embodies moral and theological truth in *Esther* and *Athalie* in

three principal ways. First, Racine emphasizes the relationship between the body's physical location and that individual's position relative to God's favor; in other words, Racine dramatizes obedience as a physical act. Second, Racine deploys both specific body parts, as well as the body as a whole, to demonstrate the incarnated presence, or absence, of the Holy Spirit in the new covenant. And, finally, Racine deploys bodies on stage as a means of illuminating the doctrine of Christ. In putting the actors' bodies to use in this way, Racine succeeds in locating obedience, piety, and the promises of God all within the physical, living, and breathing body; an embodiment of truth that his plays then implicitly call on both their participants and their audience to undertake as well.

The (Dis)Obedient Body in Space

The story of *Esther* is a story of courage and obedience. Aman, a counselor to King Assuérus of Persia, convinces the king to order the genocide of all the Jews living in the kingdom. Queen Esther, herself a Jew, is told by her uncle Mardochée that God has commanded her to appeal to the king to save her people. This Esther does, though in doing so she must choose to obey God's command despite great peril to herself.

Early in *Esther* (act I, scene iii) Esther is shocked by the sudden and unexpected approach of someone into her chamber. "Quel profane en ce lieu s'ose avancer vers nous?"—"What's he who insolently dares approach?" (I.iii.155).[13] The approaching "profane" is her uncle Mardochée, but, Esther's relative or not, his approach is quite out of the ordinary. Mardochée is entering what Racine has clearly indicated at the top of act I, scene iii is Esther's private chamber, "l'Appartement d'Esther," a place where no man ought to enter without invitation and prior announcement. Indeed, it is implied in Esther's reaction that for any man to do so would normally be considered an impossibility (presumably the queen's private chamber in the palace would be guarded). Thus, for Mardochée to simply walk into this restricted space is astonishing to Esther, and she declares that an angel must have brought him there: "Beneath his holy wings has the Lord's angel, / Concealing still your entrance, led you here?" (I.iii.157–158). In other words, Mardochée's physical presence in this place, at this moment, indicates that he is following God's lead. And Mardochée has of course done precisely that; he has come this night to Esther's chamber to deliver to her a prophetic message. Esther's people, the Jews, are about to be slaughtered, and Esther has been called by God, at this perilous moment for the Jewish nation, to reach out to the king, reveal the plots of Aman, and save her people. Thus, very early in *Esther* it is established that to follow God, that is, to actively obey God's will,

is often to literally go, physically, with one's body, to a place and into a space where one did not expect to go, and where one may not be expected or even permitted (by the profane world) to be. Thus, Mardochée has followed God by allowing God to tell him where to put his body, and, having arrived in the place to which he was called, he is in God's favor.

The relationship between Mardochée's physical place and his position vis-à-vis God's will and favor is paralleled in reverse by the circumstances of the Jewish nation in this story. The Jews are in exile. They have been banished, physically, corporeally, from the land of Israel, the land they were promised by God and that stands in the Old Testament as a symbol of God's favor toward the Jews. And the circumstances of the Jews' exile is critical here; they were exiled for sin, for rebellion against God, and their return to the promised land, and thus to God's favor, is something they dearly long for. As the chorus laments:

> O Jordan's banks! O fields beloved of God!
> Holy mountains, valleys green,
> That a hundred miracles have seen!
> For the dear land our father's trod,
> Must we ever in exile keen? (I.ii.150–154)

Thus, just as the exile of the Jews from God's favor and blessing was the result of a failure of obedience and resulted in the physical exile of their bodies from a place of their own to an alien and hostile place, so likewise the redemption of the Jews begins with a man who leaves his home for an alien and hostile place, Esther's private royal chamber, but who does so out of obedience to God. And just as the exile of the Jews to an alien place was a sign of God's disfavor toward them, so now as their redemption begins, in a reverse parallelism, Mardochée's presence in an alien place is a sign of God's favor. As Esther makes clear, he could only be there if he had been guided by an angel, that is to say, if he was highly favored by God.

But this violation of restricted space by Mardochée is only a prelude of what is to come. Indeed, Mardochée does not seem distressed by having entered Esther's chamber, since after all it is his niece that he is going to see; he can reasonably expect to be well received assuming he is able to reach her. But this is not the case when Esther is called upon to enter the king's throne room uninvited. This is a spatial violation of an entirely different magnitude. As Esther makes clear, the penalty for breaching uninvited the restricted confines of the king's throne room is death. Indeed, the bodies of the king's subjects are to be invisible to him unless he seeks them out:

> Alas! do you not know the rigorous laws
> That screen kings here from all their timorous subjects?
> Their awful majesty delights to be
> Invisible within their palace depths;
> And death's the fate of all intruders who
> Appear before them without being called. (I.iii.191–196)

Mardochée, however, makes clear that it is God's will that she must do this. And so, Esther makes up her mind, though full of fear, to obey God. Esther enters the king's throne room, uninvited, and immediately offers her body to the king to kill: "I am dying" (II.vii.635). With her body's presence, Esther has violated a space that is totally off-limits to her, and consequently she expects to die, a fact that is reinforced by Racine's stage direction immediately following Esther's line: "*Elle tombe évanouie*"— "She faints." But Esther does not die. Instead, this second violation of restricted space by an obedient body in the play is the second, and even more perilous, step toward the salvation of the displaced Jewish people. Both Mardochée and Esther have not only obeyed God, but, importantly, they have literally followed God with their bodies; they have abdicated their individual control over their bodies and have given control of their bodies and of the locations that their bodies occupy, to God.

Thus, the lesson that Racine provides for the girls of Saint-Cyr is quite particular: to obey God is to give up control of where you are and where you go. Your body is not your own. And this was not a lesson that the young women of Saint-Cyr were to learn by reading and contemplating the story of Esther. Rather, the young women enacted this physical obedience. A young woman played Mardochée entering Esther's chamber, and a young woman played Esther entering the king's throne room and falling on her face in fear. The young women enacted the obedience of the biblical characters, and in so doing learned (or at least were meant to learn) that obedience to God is not merely a matter of beliefs—it is also physical; obedience is embodied. Further, the embodied obedience of the actors/characters was witnessed by a chorus of young women who looked on throughout the play. This chorus, unique in all Racine's plays except the later *Athalie*, comprised twenty-four female students.[14] The chorus, like that in Greek drama, watches, reacts to, and comments upon the action of the play. And in the closing lines of the play the chorus states that the action of the play has led them to break into song in praise of God and to honor his name forever (III.viii.1283–1286). This is the outcome Racine intended not only for the fictional members of the chorus but for the young female performers themselves. This was a very serious message to be delivering to a group of young women prohibited from

leaving Saint-Cyr without permission and prohibited from transgressing all sorts of boundaries with their own bodies.

Like *Esther*, *Athalie* is a play about obedience to God. But in Athalie, it is disobedience, and its ruinous consequences, that is central. *Athalie* tells the story of Queen Athalie of Judah, who reigned following the death of her son, the king. Immediately upon her son's death, Athalie massacred all remaining members of the royal family including her grandchildren, thus ensuring her own ascent to power—she was an idolater who rejected the Jewish religion. However, unbeknownst to Athalie, Joas (also referred to as Eliacin), the infant heir to the throne, is secreted away and raised in hiding at the temple by Joad, the high priest, and his wife, Josabet. The action of the play begins when the boy Joas is ten years old. Athalie, having had a dream portending her overthrow at the hands of a young boy, personally comes to the temple to investigate, an action that is sacrilegious, for according to God's law, no woman, let alone an idol worshiper, is permitted within the temple grounds. At last, the boy king is revealed to Athalie from behind a drawn curtain, and she is killed by the priests of the temple.

In act II, scene ii, of *Athalie*, Zacharie (the high priest Joad's son, and a priest himself) makes clear that Athalie's decision to violate the sacred confines of the temple is an almost unspeakable horror. "A woman . . . Can I name her without sin? / A woman . . . It was Athaliah" (II.ii.395–396). And as the following lines make clear, Athalie was not welcome in the temple grounds for two very specific reasons. As Zacharie recounts, the high priest Joad told Athalie that she was not welcome due to "ton sexe et ton impiété"—"your sex and faithlessness" (II.ii.405). Thus, here is the negative example for the young women of Saint-Cyr. In Athalie, *dis*obedience is embodied. Athalie is an impious idolatress, and her rebellion against God is physically manifested by her entry into a place where God has commanded that she *not* be.

This locating of obedience in the body, its movement and location, this embodiment of obedience and disobedience by Racine in these two plays, stands in stark contrast to the assertion that the body has been exiled from the Racinian stage. Indeed, Racine goes out of his way to draw attention to it. When Esther enters the king's throne room, Racine makes a point of noting in a stage direction what happens to her body—that she faints—and the king then subsequently notes that the color has drained out of her face: "What deathly pallor / Has sudden drained the colour from her face!" (II.vii.635–636). These passages are robbed of their true impact when they are only read or imagined. To truly understand the fact that Esther has given her body to God, even, at his command, placing it in mortal peril, one must, as the watching chorus did, actually see her en-

trance, must actually see her faint, must see the color drain from her face. Or, indeed, one must, as the young woman who performed Esther did, directly embody these actions. Only then will the physical nature of her obedience be clearly understood, and, more importantly, viscerally felt. Thus, for the young women of Saint-Cyr, an unmistakable impression has been made; obedience to God means the abdication of one's rights to one's physical self. To be appropriately obedient and pious is to allow God, and his male mediums, to quite literally tell you where to go, and where you may and may not be.

The Body as Temple

In the First Letter to the Corinthians (6:19–20), the Apostle Paul says the following: "Do you not know that your body is a temple of the Holy Spirit, who is in you, whom you have received from God? You are not your own; you were bought at a price. Therefore honor God with your body."[15] In this verse is encapsulated the Christian doctrine regarding the body of the believer. Following the death and resurrection of Christ, the temple in Jerusalem ceased to be the place where God's Spirit exclusively dwelt. Henceforth, according to Christian theology, the Holy Spirit would reside literally within the body of the believer, making his or her body a temple in and of itself. Thus, as a temple, the body in Christian theology takes over the functions previously reserved for the temple of the old covenant; the body becomes the locus of worship, of God's truth, and of God's salvation.[16] How then is this notion of the human body as temple manifested in the two plays I am considering here? It is manifested in Racine's deployment of mouths, of eyes, and of the singing body.

In *Esther*, the word *bouche* (mouth) is used in a literal sense by Élise in act II, scene viii, when she worries that Aman may literally force Esther's mouth to speak blasphemy; a passage that also includes a reference to the physical eyes:

> What, if the wicked Haman [Aman], hand on sword,
> Glinting its menace in your frightened eyes,
> Against the Almighty from your mouth tries
> To force some blasphemous word? (II.ix.754–757)

Ronald Tobin has paid particular attention to Racine's focus on mouths in *Esther*. Tobin points out that the word *bouche* appears more often in *Esther* than in any other play by Racine.[17] And indeed, this focus on mouths is quite physical and concrete. As Tobin again notes, the character who speaks the word *bouche* most frequently is Esther herself. This,

Tobin argues, is because in this play it is Esther's responsibility to, quite literally, speak the truth out loud; here again, obedience is embodied, not merely understood. Esther, and the young woman playing her, is God's spokesperson, and, as such, her mouth has become the place where truth in the play is located, and through which God speaks. Conversely, the mouth of Aman, the enemy of God and his people, is identified as a locus of lies. As Tobin puts it: "As if for the sake of contrast, the first usage of *mouth* is in the phrase 'impure mouth' referring to Aman, whose actions cause consternation among the Jews, who fear being 'devoured' by their 'enemies.'"[18] Again, when Esther petitions God for help prior to embarking on her mission, she asks specifically that God will "lend my speech a charm that pleases him" (I.iv.290, my translation). Thus, Esther asks that her truth-telling emerge from her mouth, literally in pleasing tones. Once again this stands in stark contrast to Aman's voice, which, far from being pleasing to the king, is offensive to him: "Silence! / How dare you speak without your King's command!" (III.iv.1091).

Thus, Racine has removed truth-telling and lying from the abstract and located them physically as functions of the mouth, operating in the embodied act of speech. The message is obvious: the mouth of the sanctified person, as a part of the body, is a part of God's holy temple, the residence of his Holy Spirit, and, as such, is an organ of truth-telling. As the chorus says near the end of *Esther*, "She spoke—and God has done the rest" (III.ix.1227). The mouth of the unredeemed and the wicked, on the other hand, is an organ of falsehood. And note again that when Racine refers to speech he is not referring to something in the abstract; he is referring to the literal speech of the actors on stage. It is crucial, for instance, that the actress playing Esther speak during her first scene with Assuérus with precisely the kind of pleasing tones for which she has prayed to God; an actress in this role with a harsh or displeasing voice simply would not embody Racine's point with the same efficacy.[19]

Racine seems to have a special interest in eyes. As Roland Barthes put it, "In Racine there is what we might call a fetishism of the eyes."[20] This is a fact that Greenberg notes and then promptly dismisses. In Greenberg's reading, references in Racine to eyes "point to a site from which these actions [seeing] issue, but which remains itself . . . wholly subsumed in a discourse of allusion."[21] But this is an analysis that utterly ignores the embodiment of Racine's text in the bodies of the actors. Consider for example the scene in *Athalie* immediately following the revelation of Joas. First, note that this scene is highly theatrical; it depends for its dramatic impact on Athalie actually seeing the revealed boy king behind the drawn curtain. Racine then tops this reveal with the greatest moment of visual spectacle in the whole play. Racine's stage directions in this moment are

as follows: "*Here the back of the stage opens up. The interior of the Temple is seen; and from all sides armed Levites pour on the stage*" (V.v.1730). This moment of extreme visual spectacle sets the stage for the interaction that immediately follows between Joad and Athalie, in which Racine makes clear reference to the activity of Athalie's eyes:

ATHALIE
Where am I? O Treason! O Hapless queen!
I am surrounded by arms and enemies.
JOAD
In vain your eyes search, you cannot escape. (V.v.1731–1733, my translation)

Note that there is absolutely no element of allusion in Racine's reference to Athalie's eyes here. Rather, what Racine has done in this moment is to imbed an implied stage direction directly into the text. Joad says "your eyes search" implying, quite clearly, that Athalie is looking to and fro in an effort to find some means or avenue of escape, an action that makes perfect dramatic sense given the fact that she has just been surrounded by a large number of armed men.

Beyond his attention to the physical reality of his actor/character's eyes, and what they are doing on stage, Racine makes the eyes of his characters loci of worship. That is, Racine ties the proper functioning of the eyes, true sight, to the worship of the individual whose eyes they are. Simply put, when characters worship God, they see correctly and accurately; when characters worship other gods or idols, they are incapable of accurate sight. There is, of course, a metaphorical aspect to the notions of spiritual sight and spiritual blindness, and that metaphorical layer is certainly present in Racine's text. But the sight or blindness of his characters is not merely metaphorical; there is a literal aspect to it. The truth is often quite literally hidden from the eyes of the blasphemer; in *Athalie* we see this clearly.

Having had a dream that troubles her deeply, portending as it does her forthcoming demise, Athalie goes to the temple in an attempt to both discover the truth and appease the Hebrew God. However, once there, she is stunned to see the very child that she first saw in her dream. As Zacharie recounts (in a passage that also makes reference to Athalie's mouth and associates it with blasphemy):

The Queen upon him threw a savage glance
And was about to utter blasphemies.
I know not whether with his flaming sword
An angel sent by God appeared to her,
But all at once her tongue was frozen dumb

And all her pride was stricken to the dust.
Her rolling eyes, in terror, stared at us,
And most, Elias [Joas] seemed to startle her. (II.ii.407–414)

And again, when she sees Joas later to question him, she recognizes the
danger he represents clearly: "Oh Heavens! The more I look at him, the
more I'm sure / It is Him! Once more all my senses are seized with hor-
ror" (II.vii.620–621, my translation). Note again that the response to her
vision here is embodied; she is terrified, and she makes a point of not-
ing that all her senses are involved in her experience of terror. However,
despite the obviously foreboding character of her dream, and despite
having clearly recognized Joas from her dream, after Athalie meets and
speaks with the boy her sight fails her. She says ironically to Josabet, "I
go content: / I wished to see; I've seen" (II.vii.736–737). Athalie's eyes
have seen, but they have not seen rightly.

Racine goes out of his way to make this connection between true sight
and true worship, and between false sight and false worship, even more
explicit. In the fifth act, Josabet prays the following prayer in regard to
Athalie: "Put once again the blindfold ["bandeau" in the French] round
her eyes, / As when, snatching the fruit of all her crimes, / Thou hidst
her gentle victim in my breast" (V.iii.1670–1672). So, although of course
Athalie is not literally blindfolded, Josabet is asking God to perform pre-
cisely the same function, to obstruct her ability to see rightly.

David Maskell discusses the significance of the bandeau. "Bandeau"
is a word that can mean both blindfold and crown or diadem, a play on
words that is lost in English but that is important in *Athalie*. Maskell
notes the brilliant fashion in which Racine, having covered Athalie's eyes
with a metaphorical bandeau, proceeds to give her back her sight at the
very moment that she sees the literal bandeau on Joas's head: "Athalie
will indeed walk blindly into the trap, wearing a metaphorical blindfold,
but when she finally sees Joas crowned with the diadem, the visible *ban-
deau*, her eyes will be opened."[22] And this reveal has everything to do
with the ability of Athalie's eyes to see as they ought. Athalie's inability
to see rightly is here represented by the physical curtain on stage—Joas
is literally blocked from Athalie's sight. Now, however, at the command
of God, administered through his emissary the high priest, the curtain
is drawn back and Athalie is, finally, allowed to truly see. Thus, Athalie,
the blasphemer, the idolatress, cannot see the truth until it is too late;
and even then, it is only revealed to her by God's will, and only to make
clear to her the completeness of her tragic fall.

In dramatic contrast to Athalie's blindness, the chorus is able to see
quite clearly, even to the point of seeing supernatural visions of truth.

Indeed, almost immediately after Athalie, having failed to see Joas for who and what he is, has departed at the end of act II, scene vii, Racine makes clear that no such blindness has afflicted the chorus: "What star suddenly shines in our eyes? / What will this marvelous child someday be?" (II.ix.751–752, my translation). Indeed they even correctly see that there is something special about his birth, asking, "To tell us of your veiled birth is there none, / Dear child? Are you some prophet's son?" (II.ix.762–763). The chorus, then, whose worship is correctly directed toward God, has seen clearly where Athalie has not. And again, later, the vision of the chorus even extends to the prophetic. The chorus, in the midst of the coming armed crisis, is able to see past the current events to the tragic and inevitable destruction of Jerusalem and the temple, an event that, in the biblical narrative, will occur soon after the events depicted in *Athalie*. The chorus says, referring to Zion, "I see her splendour vanish from my eyes. / I see the whole world by her lustre lit. / Zion is fallen in the deepest pit" (III.viii.1220–1222). Note that the chorus here is not speaking metaphorically—they are reporting a vision of the future that they are actually seeing. Thus, once again, Racine's message to the girls of Saint-Cyr is clear: those who worship the one true God will see all things rightly; indeed, they may even experience prophetic vision, while those who reject him will be shrouded in darkness and ignorance. The eyes only function as they are meant to function, that is, they only see rightly and truly, when the body is a locus of right worship, when the body is a temple of the Holy Spirit.

It is in the singing bodies of the chorus members, however, that is found what is perhaps the most complete and cohesive representation of this theology of the body as temple. For, when the chorus members sing praises to God, they are literally transforming their entire bodies into sites of worship. The singing body is fully engaged, from the feet through the very top of the head, and all its various parts, including both the mouth and the eyes but also all the other parts as well, become involved in the expression of praise. As the chorus puts it in *Athalie*, "Sing, proclaim his loving-kindness" (I.iv.320, my translation). Thus, in the singing of the chorus, Racine's didactic employment of the bodies of his characters/actors on stage is fully consummated. The girls of Saint-Cyr are not only called to the sanctification of the various parts of their bodies but they are afforded the opportunity to achieve that sanctification. Jean-Baptiste Moreau, the composer of the choral music, wrote that the actors who were to sing his music, the young women of Saint-Cyr, had "des bouches aussi pures"—"mouths so pure,"[23] that the young women would almost become angels themselves.[24] The filling of the young women's lungs and the opening of their mouths in a full-throated song of praise to God is

the culmination and crystallization of all that has been discussed heretofore regarding the (sanctified) body as a locus of truth and worship.

Joas and the Body of Christ

Finally, having made clear both that one's personal control over one's body (where one goes and the spaces one occupies) is an expression of embodied obedience, and having made clear that the body and its various parts are most truly and rightly themselves when the body is made a temple, a habitation of the Spirit, Racine then uses the bodies on his stage to point to the incarnation itself, to the person of Jesus Christ. Racine does this, first and foremost, through the person of Joas. The body of Joas is an embodied promise. God promised David that the Messiah, the ultimate savior of the Jews, would be a king of his line. Athalie's attempt, then, to end David's line by killing his descendant was not only an act of personal vengeance, but also an attempt to rob the Jews of their promised Messiah. In the rescue of Joas, however, God's faithfulness is made manifest, and his (Joas's) body is not only a symbol of God's faithfulness to Israel, but, in a very real sense, his body *is* God's promise. He is the last of David's line, and as such the promise of a future Messiah in that line is literally embodied in him. Therefore, the revelation of Joas from behind the drawn curtain in the final scene of *Athalie* is an image and foreshadowing of the incarnation of Christ.

According to the New Testament, it is through the body of Christ (his bodily sacrifice) that the presence of God is made available to all who believe, and Joas, revealed behind the temple curtain, being Israel's king in the line of David and a forefather of Jesus, embodies the promise of this ultimate incarnation. For as the Gospel of Matthew relates, upon Christ's crucifixion the curtain of the temple was miraculously torn in two,[25] an event that signified that the presence of God was no longer contained in the Holy of Holies, the innermost chamber of the temple, but was now accessible to all believers who would henceforth through baptism consecrate their own bodies as temples of God's Spirit. Thus, in the body of Joas, miraculously preserved from death, God's ultimate promise of salvation through Christ is made physically manifest.[26] In order to perform her role well, the young woman who played Joas would have needed to understand this viscerally: that as her character endured and he/she breathed and moved, so too the promises of God endured and lived— not abstractly, but physically and concretely as embodied hope.

So Racine, then, not only a brilliant playwright but also a brilliant theologian, did not merely teach theological truths to the young women of Saint-Cyr through the plays he wrote for their benefit; Racine taught

his lessons through their embodiment by the young women who performed the plays. He managed to demonstrate to the girls precisely how a devout body ought to behave and function, and, conversely, the consequences of rebellion on the body and its operation. Thus, Racine's bodies in *Esther* and *Athalie* are didactic bodies; they are bodies that teach, instruct, and exemplify. Racine provided clear instruction to the young women of the need to be and to go where they were told, and to refrain from going or being where they were told not to, and he physically exemplified the most fundamental New Testament teaching regarding the body, that it is, or rather, that it ought to be, a temple of the Holy Spirit; a site of worship; a source of truth and praise.

Notes

1. For a discussion of the "closet drama" view of Racine's plays in scholarship prior to Maskell's book, see David Maskell, *Racine: A Theatrical Reading* (Oxford: Clarendon Press, 1991), 1–8.

2. Mitchell Greenberg, *Baroque Bodies: Psychoanalysis and the Culture of French Absolutism* (Ithaca, NY: Cornell University Press, 2001), 211. Greenberg applies the term "discursive" to Racine's tragedies in the sense meant by Foucault. It is a term that in this context implies the suppression of the corporeal by means of, almost literally, talking it to death; a kind of bondage of the body through language about the body.

3. Sylvaine Guyot, "Opacity of Theater: Reading Racine with and against Louis Marin," *Modern Language Quarterly* 77, no. 2 (June 2016): 219.

4. Sylvaine Guyot, *Racine et le corps tragique* (Paris: Presses Universitaires de France, 2014).

5. For general information on the establishment and history of Saint-Cyr, see Jean Prévot, *La Première institutrice de France: Madame de Maintenon* (Paris, Belin, 1981).

6. Raymond Picard, *Corpus Racinianum: Recueil-inventaire Des Textes Et Documents Du XVIIe Siècle Concernant Jean Racine* (Paris: Société D'édition "Les Belles Lettres," 1956), 178, 186, 188.

7. Picard, *Corpus Racinianum*, 188, my translation.

8. Ibid., 194, my translation.

9. Ibid., 182, 187.

10. Ibid., 213–14.

11. Ibid., 208, my translation.

12. Ibid., 200.

13. All French quotations from *Esther* and *Athalie* are taken from Georges Forestier, ed., *Racine: Oeuvres Complètes* (Paris: Gallimard, 1999). All English translations are taken from Samuel Solomon's translations of *Esther* and *Athalie* unless I have translated from the French myself, which is specially noted. The act, scene, and line numbers in Solomon's translations are consistent with the French:

Samuel Solomon, *The Complete Plays of Jean Racine* (New York: Random House, 1967).

14. Picard, *Corpus Racinianum*, 187.

15. All biblical quotations are taken from *Holy Bible: New International Version* (Grand Rapids, MI: Zondervan, 1996).

16. The most comprehensive biblical explanation of the body as a temple of the Holy Spirit is found in the New Testament book of Hebrews, chaps. 8–10. For its statement as a formal doctrine of the Catholic Church, see "Catechism of the Catholic Church: Part One: Section Two: Chapter One: Paragraph 6," The Vatican, accessed July 5, 2018, http://www.vatican.va/archive/ccc_css/archive/catechism/p1s2c1p6.htm.

17. Ronald Tobin, *Jean Racine Revisited* (New York: Twayne, 1999), 143.

18. Ibid., 144.

19. Similarly, in act II, scene vii (in reference to the pity that she senses growing in her heart for Joas), Athalie attributes her newfound softness in part to "la douceur de sa voix"—"the softness of his voice" (II.vii.652, my translation).

20. Roland Barthes, *On Racine*, trans. Richard Howard (New York: Hill and Wang, 1964), 22.

21. Greenberg, *Baroque Bodies*, 210.

22. Maskell, *Racine*, 88.

23. Picard, *Corpus Racinianum*, 202, my translation.

24. Ibid., 202.

25. See Matthew 27:51.

26. It is perhaps also worth pointing out that the person of Christ is also embodied in Joad, since, as high priest, he also stands in the lineage of Christ, the final and ultimate high priest (see Hebrews 4:14–16 among many passages dealing with Christ as high priest). But this lineage is a spiritual, not a literally physical (embodied) one as is the case with Joas, being a child in the genealogical line of David, the same line from which the prophets foretold that the Messiah would come.

Mike Kelly's Performance

of Success and Failure on

the Field and on the Stage

Travis Stern

ERNEST LAWRENCE THAYER'S poem "Casey at the Bat: A Ballad of the Republic, Sung in the Year 1888" was first published in the *San Francisco Examiner* on June 3, 1888. It grew in popularity in the United States after English actor DeWolf Hopper integrated it into his repertoire in 1892.[1] Controversy emerged over who might have been the real-life inspiration for the fictional slugger. Fueling speculation, a month after its debut, the *Sporting Times* published the last eight verses of the original poem but changed the name of the titular star baseball player from Casey to Kelly. Shortly after the amended poem's publication, rumors suggested that not only was popular Boston player Mike Kelly the inspiration for the character, but he may have also been the poem's true author. Fond of a good story, Kelly did nothing to dismiss these rumors and perpetuated the popular idea that the poem may have been at least based on him.[2]

After having started his career with two years in Cincinnati, Michael "King" Kelly emerged as an exceptional player for the Chicago team in the National League from 1880 through 1886, leading the league in batting average and runs scored multiple times. He had three remarkable seasons with the Boston National League team from 1887 through 1889 before bouncing between teams in several leagues over the final five years of his career. Kelly was one of professional baseball's first nationally recognized stars—often later called baseball's "Babe Ruth before Babe Ruth."[3] By the time "Casey at the Bat" debuted, Kelly's interaction with crowds and the admiration he received from them, which mark Casey's demeanor in the poem, were already an established part of the real ball player's image. He was flamboyant, dramatic, and perceived to be the best player

on many of his teams, and he likely would have represented the Mudville fans' best hope to win the game in the situation presented by the poem. When Kelly began performing on vaudeville stages in 1893, he included a recitation of "Casey" as the final piece of his act.

In the late nineteenth century, theatre and professional baseball had a fluid, interconnected relationship that had multiple economic benefits for both industries when a professional baseball player transferred his playing persona to the stage. Whether it was by performing in multi-act plays or by performing in vaudeville, players who wanted a chance to make money on the stage would first have had to achieve some recognition within the baseball world through establishing a persona. A player's persona was composed of their on-field achievements as well as their way of playing the game. While some achievements were quantifiable through statistics and understandable by checking the printed box scores, it was often the style a player had, which could be viewable in game-to-game performance, that distinguished a player's persona. Newspaper stories provided colorful descriptions of how a player ran, batted, or threw, and certainly the subjective nature of those reports did influence public perception of a player. However, the appeal for the fan was not from reading accounts of the player's feats, but from seeing the player in person. By attending the game and being in the physical presence of the player, local fans were able to discern for themselves the style with which the player played the game. The attitude he possessed while playing, as seen in his physique and ability, and the general demeanor he reflected, often in verbal exclamations or witticisms, were key to the player's style.

Built from both previous accomplishments as well as the player's style, the baseball persona of a player was imbued with what Cormac Power, in his book *Presence in Play*, termed "auratic presence." Power develops the term by using "aura" to refer to the extraordinary aspects of an object's presence that exist beyond just physically being present. He suggests that one way the auratic presence can exist is through the fame or reputation of the present object itself in combination with the knowledge and expectations that an audience possesses at the time of the experience.[4] A player stepping on the field, for example, carried with him the aura of his playing persona, which helped create interest and excitement for an audience. Further, the act of performance itself can also construct the auratic presence.[5] As such, the aura is always a combination of the past and immediate present. The player who excelled yesterday may be lackluster today, but the accumulation of these events makes him worth watching. The body of a performer can thus both hold an aura and create an aura through the act of performance.

Having such an aura made particular players an attraction as they trav-

eled the league circuit, and it helped make those players celebrities within baseball. Chris Rojek offers up several classifications of the types of celebrity in his book *Celebrity*. People who have what Rojek calls "achieved celebrity" have gained their recognition through open competition where success and failure were apparent to the audience. Achieved celebrities need neither a lineage of previous celebrity nor verification by a social mediator, and they have a social distance from their audience by having their talents on display to people who have no interpersonal relationship to them.[6] Professional baseball players achieved their celebrity through successes that were clearly visible.

I argue that Kelly's conscious performance and embodiment of what became his baseball persona while on stage are complicated by his changing status in celebrity over the years. By first describing how his persona was constructed both before and after his leap to celebrity, I am then able to examine how those ideas transferred with Kelly to the stage. Playing larger venues in multi-act dramas and on vaudeville stages, Kelly embodied the success and affluence aspects of his persona, but as his baseball career began to fade, his embodiment of that persona reflected that decline. Performing in more intimate surroundings, removed from the social distance required by celebrity, Kelly's performance failed to embody those same ideas, thus spotlighting the human instead of the image.

In building his baseball persona, Kelly was always conspicuous on the field. While his statistics and on-field accomplishments placed him among the elite players in the game at the time, it was Kelly's playing style that truly distinguished him from many of his contemporaries. Highly regarded by other players for his intelligence, Kelly was cited as either an innovator of, or contributor to, the development of several tactics still used in the game today, such as the hit-and-run play, hand signals to communicate to the pitcher, and his innovative technique of sliding around the base rather than directly to it to give his opponent less of an opportunity to tag him out.[7] Kelly's playing helped propel Chicago to multiple National League championships, and he was called by one teammate the "life and soul of the Chicagos."[8] Stories circulated of Kelly's exploits in seeking any advantage available, such as purposely skipping bases on his way to home plate while the umpire was not looking, thus shortening the distance he had to run.[9] Many times Kelly's actions in these situations were technically within the established league rules, or served to highlight the lack thereof, and created for him an aura of playfulness and excitement that made him a player that people wanted to witness.

Fans did more than just see Kelly at the ballpark, as his constant chatter served to make the game more of an entertaining spectacle. Kelly's verbal exhibition allowed him to interact with the crowd, as when he

would needle the other team's fans by boasting about his own skill or by taunting the other team; in turn, fans made Kelly a target when he made a mistake or his team was behind. Playing a game in Indianapolis, Kelly drew a walk and then called out "razzle-dazzle" to the home fans. Later thrown out at the plate, he heard the same fans return the call toward him. Kelly reportedly lifted his cap and bowed.[10] He also used his time on the field to give his spoken replies to the things written about him in the newspapers. The displays of Kelly's physical ingenuity and verbal raillery as well as the proliferation of the stories of his tricks helped imbue Kelly with a presence that made people want to go to the ballpark to cheer or boo his antics. From his first to his second season with the Chicago team, the average per-game attendance jumped by 400, and as the team moved into a new park for the 1882 season, attendance averaged 3,000 per game, which was an increase of more than 1,000 per game from the previous year. With a fan-focused player like Kelly also contributing to a winning team, Chicago was a very popular and profitable ball club.[11]

Through all these actions and achievements, Kelly had acquired a goodly amount of fame in baseball: players knew they had to be aware of his tricks, sportswriters regularly reported his exploits, and fans came to the games to watch him. These qualities alone would have provided him an avenue to pursue stage work as a way to supplement his baseball salary. However, at this point Kelly's fame remained localized and primarily within the game. Using sociologist Chris Rojek's classifications of levels of fame in the modern world, Kelly would be classified as being renowned, but at this point in his career he would not yet have reached status as a full celebrity. For Rojek, the distinguishing characteristic is the proximity of the famous to those who are paying attention. The renowned individual maintains a social or para-social level of contact with the audience much the same as Kelly did through his interactions with fans. The crowd sees themselves on the same level socially as the renowned. They can interact with relative ease. The leap to celebrity requires more distance between the famous person and the audience that serves to separate the two from each other. For Kelly, the event that distanced him from his audience and put him at the celebrity level was his sale to Boston and the resulting association of his image with the acquisition and embodiment of wealth.[12]

Following a dispute with the Chicago club ownership after the 1886 season, the Boston club secured Kelly's release for the extraordinary figure of $10,000, an amount unprecedented in both the game and American society in general. Rights to a player had been sold before, but none for so high a price, nor had the player himself benefitted from the transaction.[13] The number immediately became associated with Kelly, whose

sale price coincided with the advertising slogan used by circus owner Adam Forepaugh's beauty contest winners, and he instantly took on the mocking title of the "$10,000 Beauty."[14] The figure became ubiquitous in newspapers nationwide as well as in Boston, where they publicized a $10,000 life insurance policy on Kelly, and put the certified purchase check for his contract on display in Boston club owner Arthur Soden's office.[15] While receiving none of the purchase price himself, upon arrival in Boston Kelly's salary was raised to $4,000—twice the maximum salary allowed by the league.[16]

Though the large amount of money associated with Kelly was unique among baseball players, it seemed even larger in comparison to what his fans were familiar with in their own lives. American industrial workers averaged approximately $480 in annual earnings in 1890, which meant that Kelly's annual salary for a few months' work was ten times what the average fan in attendance would make in a year.[17]

After the purchase and its surrounding publicity, Kelly quickly became recognized as baseball's most valuable player under a statistic that even non-fans could understand: money. The persona he had built based on success and showmanship was now inextricably tied to wealth. What this rebranding effectively did for Kelly was to elevate him beyond a valuable baseball player into a star attraction. An instant celebrity.

Whether a celebrity or not, once a public persona is established, associated ideas must be perpetuated to become aspects of that persona, and a key component of sustaining Kelly's identification with wealth was his embodiment of affluence, seen at the ballpark, around the city, and reported in the newspapers. In public ceremonies at the ballpark, fans presented him with gifts ranging from medals and trinkets to a horse and carriage, even to an entire cottage located in South Hingham, Massachusetts.[18] In addition to these valuable presents, newspapers reported that Kelly had multiple sources of income beyond his baseball salary. Even before his sale, used perhaps as a negotiating ploy in his standoff against the Chicago ownership, a newspaper reported that Kelly may not choose to continue his baseball career because he had apparently made over $100,000 from speculating on wheat after the 1886 season. Reports stated that the sale of his book, *Play Ball: Stories of the Diamond Field*, brought him $1,500 within just a few months in 1888.[19] He told the *New York World* that spending much of what you earned was one of the requirements of being a star, and Kelly further displayed his affluence by his conspicuous wardrobe.[20] Unlike other professional players, he dressed only in the most current, imported fashions, often highly accessorized with items such as diamonds or a gold-topped cane, as well as a variety of small lap dogs.[21] Capitalizing on the cultural link of wealth to success,

Kelly became proficient in presenting himself as an embodiment of the success of his work rather than remaining tied to the image of the work he did as a ballplayer. He was still identifiable as a ballplayer but, by presenting himself as of a higher, nonworking class, he was identifying with the fruits of the labor rather than the labor itself.

The most prominent way Kelly spent his money and time was in drinking. Following the 1888 season, Kelly partnered with a former umpire named John Kelly to open a New York bar called "The Two Kels" that was doing so well, he claimed, that he couldn't leave it to complete a promised trip with an all-star team to Australia.[22] The primary duty in his bar ownership endeavor was merely to be present at the location so that patrons might be able to see and drink with "King" Kelly, baseball's celebrity attraction.[23] His former Chicago manager, Cap Anson, later wrote that Kelly's fondness for whiskey allowed money to slip through his fingers like "water slips through the meshes of a fisherman's net."[24] His former owner in Chicago, Al Spalding, a well-known temperance supporter, used fines and withholding of payment in an effort to keep his players from drinking, and he hired a private investigator to report particularly on Kelly's off-field habits. A detective reported to Spalding that he had seen Kelly in a saloon on Clark Street at three in the morning but sanitized the story by saying that Kelly had only been drinking lemonade. Kelly corrected the report, stating publicly, "I never drank a lemonade at that hour in my life. It was straight whiskey!"[25]

In 1886 alone, Kelly lost $325, or about 20 percent from his contract, in fines as a result of his drinking. The toll on Kelly's body itself may have been more costly. His physical skills declined year by year, and his drinking took the blame. He regularly asserted that he was going to cease drinking to improve his playing. As a fan teased him with a bottle, Kelly told him to save it for the off-season because he was staying on cold water all summer long. Additionally, references to his drinking were often coded as concerns about his weight, which Kelly asserted was under his control during the playing season. He told a reporter one off-season that while he currently weighed 212 pounds, he had never weighed more than 169 during the entire previous season.[26]

It is within this context that Kelly performed on stage in multi-act dramas. Rather than enacting only the baseball-related aspects of his aura, as many of his contemporaries had when they went on stage, Kelly continued to embody the ideals of wealth and success with which he was associated.[27] On March 26, 1888, Kelly played the role of Dusty Bob in Charles Hale Hoyt's *A Rag Baby* at the Park Theatre in Boston. At Kelly's first appearance in the third and final act, the show stopped for several minutes due to the large and loud reception he received for stepping on-

stage.[28] The role of Dusty Bob required Kelly to storm the stage look-ing to fight the play's protagonist, Old Sport. Having found him, Bob is quickly defeated and thrown into the cellar with the door shut behind him. He emerges from the cellar alone on the stage with a bear trap at-tached to the back of his trousers, providing a sight gag as he exits. The play was written before Kelly's ascent to stardom both on and off the field, so it was clearly not written to encompass his persona, but his em-bodiment of the role served to highlight comparisons between the two. Dusty Bob is brought from out of town to beat Old Sport and is intent on doing the job that his employers have paid him to do. Kelly's auratic presence in that role already held the remunerative fame he had gotten upon coming to the city. With Kelly recognizable in the role, Bob and Kelly are essentially one body. That he is easily and quickly defeated shows not only the relative strength of the protagonist but also how humorous it would be to see Kelly fail because of the presumed incongruity.

Kelly continued his performances in full-length dramas when he par-ticipated in another of Hoyt's productions, beginning a two-week run on December 24, 1888, as the tough Rob Graves in *A Tin Soldier* at the Fourteenth St. Theatre in New York. As in *A Rag Baby*, Kelly's role as Rob Graves in *A Tin Soldier* required him to fight. Graves overhears a character say that he would pay ten dollars to have another character beaten up. Graves demands fifteen, and once the character says that he would make it twenty-five if done well, Graves replies, "Young feller, I'll blot him off the earth."[29] Though he loses the offstage fight that closes the first act, Graves returns in the third act when another character needs more fighting done. Graves asks for fifty dollars but eventually agrees to do it for five and admits that it will force him to postpone his grave rob-bing plans for the night. At the conclusion, Graves delivers the play's final line, comically demanding his five dollars. As Kelly had two full baseball seasons behind him as a star, the advance publicity for the production played up Kelly's public persona. Reportedly Kelly originally asked the Hoyt & Thomas Company for $2,000 to appear in the small role but was negotiated down to $1,000 and a new overcoat. In a puff piece adver-tising the production, the *New York World* reported that the price Kelly got was the largest given to a nonactor. Hoyt stated in the piece that he believed that Kelly would draw in more than enough money to make up his salary.[30] Seeing Kelly in the role, the audience viewed two separate onstage negotiations for more money, which matched the offstage image of Kelly promoted in the publicity. The play's final line reinforced this association, as Kelly's character demanded payment for a job not done particularly well in the play, just as Kelly's performance onstage may not have been expertly accomplished since he was not a professional actor.

In both of these cases, the fusion of Kelly's body and the fictional characters serves to reinforce the persona he created. The characters highlighted the success-and-affluence narrative associated with his persona. As a celebrity, Kelly's body was always visible to the audience in the role rather than eclipsed by the body of the character. It is Kelly, not Dusty Bob, whose failure is ridiculous and comical. It is Kelly, not Rob Graves, who negotiates remuneration for his impending physical work. Through Kelly's embodiment, both roles are in essence performances of his persona.

As it was part of what designated him as extraordinary, Kelly's financial success was obviously the exception to the rule among professional players. Upset over what they considered to be unfair working conditions in the National League, in the late 1880s the players organized into a collective called the Brotherhood of Professional Base Ball Players. In an effort to withhold their labor from the owners, after the 1889 season the Brotherhood formed the Players League with teams in the same cities as the National League and the American Association as direct competition to those organizations, thus allowing players to switch allegiances to the new league while staying in the same city.[31] Kelly was one of the Brotherhood's biggest supporters.

At Hooley's Theatre in Chicago on Thanksgiving Day 1889, Kelly and playwright Charles Hale Hoyt came onstage and interrupted Hoyt's play *A Brass Monkey* after the beginning of the second act. Hoyt introduced Kelly to the audience and, taking the pen and ink from the actor portraying the auctioneer, had Kelly sign his Brotherhood contract in view of the audience. By putting Kelly onstage for this bit of public advertising, the new league borrowed Kelly's image of wealth and success as a means to promote an association with success for the new league. Chicago was the city that may have most needed this kind of advertisement, since the most notable name who had not switched allegiances to the new league was that city's Cap Anson.[32] Clearly it was important for Kelly's connection to the league to be visible for both Kelly and the league itself. Kelly still presented himself as the embodiment of success and affluence, two things the new league was desperate to have associated with it. As celebrity requires visibility, Kelly's presence onstage in full view and awareness of the audience made a mundane event—the signing of a contract—a dramatic one. The body being presented onstage that night in Chicago and that could have long been seen in the city's National League ballpark would no longer appear there once that signature was completed. Once he walked off the stage with Hoyt, there would be only one place he could be seen playing next season, and that was in a Players League ballpark.

It was no surprise that within a few years Kelly tried to capitalize on

the quick wit the crowds had seen him display on the ball field by working a vaudeville act that was specifically tailored to his personality. Beginning on January 16, 1893, Kelly partnered with Billy Jerome in a vaudeville act.[33] For most professional performers in the late nineteenth century, who began their careers in multi-act, full-length plays, moving to working in a vaudeville house was a clear step down. There certainly was a loss of prestige associated with such a move, and actors usually suffered as well from a combination of reduced pay and an irregular work schedule. For performers who relied on performing as their career, this transition from standard playhouses to vaudeville houses was often one that was done out of desperation. Kelly, whose performances in multi-act dramas were not his sole means of support, had little to lose by playing in vaudeville, and the trade-off was the ability to control the presentation of his image more directly, with songs and skits written specifically for him and his abilities. Regardless of any perceived loss of prestige, the persona he continued to display onstage maintained the themes of wealth and success that had by now become synonymous with his name.

In addition to several comic bits and banter between the two partners, Kelly's act with Jerome featured several comic songs, including one called "Papa Wouldn't Buy Me a Bow Wow." Kelly also sang a short comic verse about continuing to play in the Bowery if his Boston team refused to pay him his salary and the New York team did not want him. In an interview with the *Chicago Record*, Jerome discussed how Kelly could make more money onstage since the Boston team would not pay Kelly's demand of $3,000 for the season. Jerome said, "You see, 'Kell' has been drawing the biggest salary of 'em all and he can't afford to accept a cut like that. When he once accepts a cut he will never get up again." At the time, Kelly was earning about $150 a week in the Jerome vaudeville act.[34] His image now also incorporated the publicity surrounding his financial successes from his appearances in Hoyt's plays by using part of the act as a public negotiation for more money. This was in part because, by this point in 1893, Kelly's fluidity of wealth had much more going out than coming in.

This change in venues was a permanent one for Kelly, as he never played in a multi-act drama again once he began playing in vaudeville. Still a draw, however, Kelly's presence in the vaudeville houses served as a de facto declaration or assertion of continued celebrity—almost a reminder of the past to the audience—and it depended on the juxtaposition of his long-standing aura with the physical form that was now on display. He had experienced a similar decline on the ballfield as well, where the contrast between his celebrity and his reality was much more visible.

Kelly had a successful year in the Players League on the field, and he also managed the Boston team to the championship. However, the league

itself folded after one season. The Players League put a good product on the field, but it ultimately could not compete with the two more established leagues. Remaining notably resolute in not returning to the National League, Kelly joined the Cincinnati team of the American Association for the 1891 season. As the Cincinnati team began to struggle financially, the league moved the team to Milwaukee for the final few weeks of the season. Kelly was then allowed to join the league's Boston franchise, where the league believed his celebrity could provide a boost to attendance. After only eight days with the Boston AA team, Kelly admitted defeat and returned to the National League team in the same city. His ultimate retreat back to the National League gave him a very visible association with failure, and his aura from the past had begun to be eclipsed by the realities of the present.[35]

Kelly was indeed finding himself more frequently acquainted with failure than he had been while playing baseball, and nearly all the achievements that had contributed to his celebrated persona were in the past with little possibility of enhancing his aura through his present performance. His 1892 season was the worst of his career, and the thirty-four-year-old posted personal lows in nearly every major statistical category. In the 1893 season, as alluded to in his vaudeville act, though the Boston National League team kept Kelly on reserve, they were unwilling to meet a salary demand that they felt was no longer equal to his ability, and loaned him to the New York team in the same league. Kelly appeared in only twenty games for New York in 1893 and was reportedly out of shape the entire season, which likely prevented him from playing in the major leagues again. Kelly's decline made his physique nearly incompatible with the playing persona from his early career. Unable to take off the weight during the season, he was slow on the field, and the yearly published sporting guides noted his arm had become steadily weaker throughout the last decade.[36] Fans who had once attended games to see Kelly saw now a body that was incongruous to his aura. The achievements that had been the first element of his budding celebrity were no longer likely, and the only remaining aspect of his celebrity was the distance from social contact with the crowd that performances in vaudeville provided. Though he remained witty and verbose, fans no longer had to attend the ballpark to hear him. They could go to a vaudeville house.

Kelly continued performing various routines in vaudeville, but the recitation of "Casey at the Bat" remained constant. Kelly had liked being the center of attention, but it is clear he had trouble being put on the spot while performing. For all his theatrical activity, Kelly maintained a consistent case of stage fright even in front of the friendliest audiences, sometimes refusing to return for an encore after having left the

stage once "Casey" was complete.[37] Perhaps out of fear that he was going to be called to give his rendition next, Kelly reportedly left a performance attended by the players of four different teams when they called for DeWolf Hopper to recite the poem.[38]

Not a trained actor like Hopper, Kelly had a delivery that would have been considered good for a ballplayer, but his performance of the poem apparently ranged wildly. One review derided his "sing-song, school-boy" recitation, while another noted his soft voice, nervous manner, and unorthodox gestures, and described his delivery of the moment when Casey quiets the crowd "as though it were a poem on the death of a child."[39] The advantage that Kelly's recitation had over Hopper's, and what made it a hit with audiences, was the possibility that the story could be seen as autobiographical for the man performing it in front of them. At times in his theatrical career, Kelly had used failure as a comic contrast to his persona of success, and the failure of Casey/Kelly at the end of the poem may have been intended to serve him in the same mold. However, Kelly began reciting the poem as his baseball talents had started to erode, and his inability to perform the poem in an aesthetically pleasing way added to this perception by uniting failure and authenticity. It wasn't an actor performing. It was a baseball player. It fused the image and the man by allowing the audience to see past the aura to the physical reality of the moment.

However, Kelly did seem much more comfortable when he felt he was surrounded by friends rather than put on display in a theatre. One place he did feel at ease was in bar rooms surrounded by his fans and fellow Elks brethren, where his performances of the poem on command added a further layer to his embodiment of Casey. He was no longer the embodiment of wealth and success, and by reciting the poem here, he was freely giving away one of his main sources of income. With the final agent of his celebrity removed—the distance between a celebrity and their audience—his persona's aura relied almost entirely on things incongruous with his present. Kelly's presence in the pub—a place of recognized horizontal comradeship and community—placed him back in the parasocial contact with the audience that marks the realm of renown while simultaneously enacting the conditions that made him a celebrity. His recitations of "Casey at the Bat" were infused with an auratic presence that was now more closely associated with failure than with success and embodied by someone who seemed more suited to being in the crowd than on the field.

Kelly serves as a good example of the capricious nature of transferring achieved celebrity based on physicality to another arena where the body is also put on display. As the aura becomes incongruous with the

body that it is attached to, humanity begins to eclipse celebrity. As such, Kelly's embodiment of "Casey" was imbued with the auratic amalgam of his images: he was at once the "$10,000 Beauty," the admired ballplayer, imaginative and unmatched on the field; and at the same time he was an aging icon, a less than talented performer who had been on a theatrical descent from full-length plays to vaudeville from the moment he began to appear on stage. Present in these smaller rooms, Kelly could be more human than star, and the tale of the failure of Casey to hit the ball was delivered by both the great hope legendary image who was approaching the plate and, simultaneously, by the body that seemed to have just swung and missed for the third time. One article reflecting on his entire career, well after his death in November 1894, noted that reviews for Kelly's performances featured "a lot less applause when he finished than when he entered."[40]

Notes

1. Eugene C. Murdock, *Mighty Casey: All American* (Westport, CT: Greenwood, 1984), 5–6.

2. Howard W. Rosenberg, *Cap Anson 2: The Theatrical and Kingly Mike Kelly, U.S. Team Sport's First Media Sensation and Baseball's Original Casey at the Bat* (n.p.: Tile Books, 2004), 9; Jim Moore and Natalie Vermilyea, *Ernest Thayer's "Casey at the Bat": Background and Characters of Baseball's Most Famous Poem* (Jefferson, NC: McFarland, 1994), 237–39. Thayer would later maintain that there was no single player who was the basis for Casey.

3. Randy Roberts and Carson Cunningham, *Before the Curse: the Chicago Cubs' Glory Years, 1870–1945* (Urbana: University of Illinois Press, 2012), 49. Mark Hartsell, "Baseball Americana: Baseball's Greatest Hits," *Library of Congress*, May 18, 2018, https://blogs.loc.gov/loc/2018/05/baseball-americana-baseballs-greatest-hits/. Marty Appel, *Slide, Kelly, Slide: The Wild Life and Times of Mike "King" Kelly, Baseball's First Superstar* (Lanham, MD: Scarecrow, 1996), xi. Sam Flynn, "Griffin Speaks on History of Irish Immigration in America," *The Chautauquan Daily*, July 14, 2015, https://chqdaily.wordpress.com/2015/07/14/griffin-speaks-on-history-of-irish-immigration-in-america/.

4. Cormac Power, *Presence in Play: A Critique of Presence in the Theatre* (Amsterdam: Rodopi, 2008), 47.

5. Ibid., 49.

6. Chris Rojek, *Celebrity* (London: Reaktion, 2001), 12, 17–20.

7. Appel, *Slide, Kelly, Slide*, 42; Mike Kelly, *Play Ball: Stories of the Diamond Field* (Boston: Press of Emery and Hughes, c. 1888; reprint, Jefferson, NC: McFarland, 2006), 25; Rosenberg, *Cap Anson 2*, 7.

8. "Ed Williamson on Kelly's Release," Mike "King" Kelly player file, A. Bartlett Giamatti Research Center, National Baseball Hall of Fame and Museum, Cooperstown, NY.

9. Rosenberg, *Cap Anson 2*, 4; *Chicago Tribune*, September 22, 1881; Kelly, *Play Ball*, 34–35.

10. Rosenberg, *Cap Anson 2*, 29.

11. "Chicago Cubs Attendance Data," Baseball Almanac, http://www.baseball-almanac.com/teams/cubsatte.shtml, accessed July 26, 2018. Attendance figures on this website are accumulated from *Sporting News* and *New York Times* reports.

12. Rojek, *Celebrity*, 12.

13. The previous records for selling a player had actually come from entire teams being sold to another club and the new club choosing which players it would like to keep. On October 30, 1864, the Columbus Buckeyes were sold to the Pittsburgh Alleghenys for $8,000, with ten players retained by the purchasing club. On September 16, 1885, the Buffalo Bisons were sold to the Detroit Wolverines for $7,000, with four players remaining on the new team. www.retrosheet.org.

14. S. L. Kotar and J. E. Gessler, *The Rise of the American Circus, 1716–1899* (Jefferson, NC: McFarland, 2011), 242.

15. Appel, *Slide, Kelly, Slide*, 105; *New York Herald*, February 16, 1887.

16. The agreement that Boston reached with Kelly upon his arrival was to receive the maximum yearly salary of $2,000 as well as an additional fee for the team to use his picture for advertising purposes—a right the team already owned in the standard player contract. Appel, *Slide, Kelly, Slide*, 104.

17. Kelly was earning as much per year as U.S. senators, and the sale price with which he was associated topped the annual salaries of the vice president and cabinet secretaries. Robert A. Margo, "Annual Earnings in Selected Industries and Occupations: 1890–1926," in *Historical Statistics of the United States*, vol. 2, millennial ed. (New York: Cambridge University Press, 2000), 2–271; "Senate Salaries since 1789," United States Senate, http://www.senate.gov/artandhistory/history/common/briefing/senate_salaries.htm, accessed July 26, 2018; "United States Government March 4, 1893," USGenNet, http://www.usgennet.org/usa/topic/preservation/gov/usgov.htm, accessed July 26, 2018.

18. Rosenberg, *Cap Anson 2*, 185.

19. *Boston Globe*, November 4, 1888.

20. Rosenberg, *Cap Anson 2*, 230.

21. Ibid., 30, 116, 143, 156, 161, 168, 180.

22. *Boston Globe*, December 22, 1888. The two Kellys were not related to each other.

23. Rosenberg, *Cap Anson 2*, 160.

24. Adrian Anson, *A Ball Player's Career* (Chicago: Era, 1900), 115.

25. Appel, *Slide, Kelly, Slide*, 99.

26. Rosenberg, *Cap Anson 2*, 110, 163–64, 230.

27. Harold Seymour and Dorothy Seymour Mills, *Baseball: The Early Years* (New York: Oxford University Press, 1960), 333, provides an example of other players seeking work on the stage during this era.

28. *Boston Herald*, March 27, 1888; Rosenberg, *Cap Anson 2*, 45.

29. Charles Hale Hoyt, *A Tin Soldier* in *The Dramatic Works of Charles H. Hoyt* (New York: 1901), 39.

30. *New York World*, December 17, 1888.

31. Seymour and Mills, *The Early Years*, 221–50.

32. *Buffalo Express*, December 2, 1889.

33. *New York Clipper*, January 21, 1893.

34. Rosenberg, *Cap Anson 2*, 51.

35. "Setting the Pace," Kelly player file, National Baseball Hall of Fame.

36. Appel, *Slide, Kelly, Slide*, 165.

37. Rosenberg, *Cap Anson 2*, 48.

38. *New York Daily Tribune*, June 11, 1893.

39. Rosenberg, *Cap Anson 2*, 50, 228.

40. Asa Bordages, "2 Things Kelly Could Do, Play Smart Baseball and Drink Straight Whisky," *New York World-Telegram*, May 13, 1939, Kelly player file, National Baseball Hall of Fame.

Miss Julie via Manda Björling,

1906–1912

Embodiment, Conceptual Blending, and Reception

Lawrence D. Smith

A T THE TIME OF ITS premiere in Stockholm, Sweden's capital city, in 1906, August Strindberg's *Miss Julie* had been in print for over eighteen years and was familiar to Swedish audiences almost exclusively as a published text rather than through performance.[1] Journalistic responses to the 1906 production particularly emphasize the issue of the performer's body in relation to the text, and especially the actor's physicality compared to the fictive body of the title character. This paper applies theories of embodied cognitive processes, in particular conceptual blending, to an analysis of primary sources detailing audience responses to Manda Linderoth-Björling (1876–1960) in the title role. The framing question for this analysis is: How did fundamental cognitive processes, which are largely unconscious, inform the critical reception of Manda Björling as Miss Julie for spectators more familiar with their own embodied "blends" of the character?

"Embodiment" is used here to identify a number of neurocognitive processes from which consciousness and conceptual thinking arise. Some of the embodied processes considered here include our attunement to faces, voices, and intentional gestures; how language and meaning-making are embodied; and how emotions are embodied experiences that dispose one toward taking action (or "concern-based construals").[2] These everyday processes (evolutionary, biological endowments, shaped by cultural practices) when engaged in hypothetical play, such as a drama, shape a spectator's perception of an actor/character. They are what make aesthetic, mimetic performance possible for us, and they are a means of understanding, at least in part, the responses of historical audiences.

Theoretically, one such process, "conceptual blending," is essential to playwriting, acting, and audience engagement.[3] For example, the composition of *Miss Julie* occurred within a very tight timeframe of about six weeks between July 1 and August 10, 1888, and within very turbulent lived circumstances for the playwright.[4] This composition process may best be understood by applying the theory of "conceptual blending" and the related idea of "input spaces" developed by Gilles Fauconnier and Mark Turner. "Inputs" (or "mental spaces") are a key component in the model of conceptual blending. Described as discrete "conceptual packets" that are constructed during thought and speech (or writing) "for the purposes of local understanding and action," several inputs may serve to provide concepts (in the case of a play, dramatis personae and actions) that can be combined in a "blended" or "fourth space" (a hypothetical scenario).[5] Constructing a blend is selective but also occurs largely on a preconscious (or intuitive) level. In the case of *Miss Julie*, some of the real-life people and events that Strindberg knew and seems to have drawn upon in creating the title character, such as Siri von Essen (1850–1912), his estranged spouse; the Danish author Victoria Benedictsson (1850–1888) and her multiple suicide attempts; and the Countess Anna Louisa Frankenau (1848–?), in whose dilapidated villa Strindberg and his family lived before and during the writing of the play, each provided "input spaces" resulting in a conceptual blend ("Miss Julie"), without Miss Julie *being* any of those three persons. Somewhat presciently, Strindberg describes his "characterless characters" in an analogous manner as "conglomerates of past and present stages of culture, bits out of books and newspapers, scraps of humanity, torn shreds of once fine clothing now turned to rags, exactly as the human soul is patched together."[6] Considering such elements as "inputs" illustrates how selective information from discrete experiences were combined, reassembled, and reconfigured in *Miss Julie* without reducing the text to an autobiographical document. The process of "conceptual blending" extends to the experiences of reading, performing, and watching a play.[7]

Miss Julie, along with the author's preface, was published in Sweden in the fall of 1888 and acquired an enthusiastic readership. But due to official censorship and the restrictions of social convention, production of the play was sporadic and far-flung. The inauspicious "world" premiere was by Strindberg's own short-lived Scandinavian Experimental Theatre in March 1889, and featured von Essen in the title role. This bilingual production (Julie spoke Swedish while Jean and Kristin spoke Danish) was performed privately at the University Student's Union in Copenhagen, Denmark, due to the play's controversial content. For the next eighteen years, this ostensibly Swedish cultural product was performed abroad,

the most significant productions occurring in 1893 in Paris at Théâtre Libre, directed by André Antoine (1858–1943), and in 1904 in Berlin at the Kleines Theatre, directed by Max Reinhardt (1873–1943).[8] Thus, apart from its availability in print, and despite Strindberg's increasing cultural prominence in Sweden, opportunities to encounter the character of Miss Julie embodied in performance by an actress were available only upon international stages. So when a small provincial troupe run by August Falck (1882–1938) undertook the Swedish premiere of the play in September 1906 and subsequently brought this production to Stockholm the following December, it became a theatrical cause célèbre.

The debut of the play at the Folk Theatre in December 1906 presumably was a first encounter with a "Miss Julie" embodied by an actor in performance for all audience members, including the reviewers. It is clear that the performance was therefore a "novel case" in many respects, albeit one that was crucially informed by familiarity with the play as a published text. In Manda Björling, these readers-turned-spectators faced an unknown actor. Björling had embarked upon a stage career only a few years earlier and, at the time of this photograph, she was thirty years old, a divorced single parent making her Stockholm debut (figure 4.1). Audiences found themselves in the presence of a tall figure with a mild voice, a young actor at times uncertain in her gestures, but capable of possessing herself and the stage with a tangible sense of artistry and intelligence, who "captured one's attention with her individuality."[9]

In many reviews, the response to this novel case was positive, and evidenced the primary emotion of surprise: "It is nevertheless a *pleasure* to say that August Falck Junior's company, which has come here to Stockholm in order for us to see for the *first time Miss Julie*, in a manner that *unexpectedly succeeded* in terms of what the piece itself amounts to, a *daring experiment*."[10] In addition to surprise, this review also indicates an aesthetic pleasure brought about by the performance, or what has been termed "production" or "artifact" emotion (i.e., responses to features of a dramatic performance that lie outside of the fictive circumstances of the plot).[11] Specifically, "pleasure," "unexpected," and "daring experiment" convey the qualities of primary and artifact emotions experienced by the reviewer, in this case *surprise* and *admiration*. In a similar vein, another reviewer attested, "There is something *refreshing* and *pleasant* to the nerves to *suddenly* be sitting face to face with very different actors than those one is familiar with."[12] In addition to conveying surprise and pleasure, this reviewer's emphasis on being "face-to-face" captures both the fact of the approximate closeness between the performers and the audience, as well as our neurocognitive sensitivity to faces; the human brain has dedicated face-selective areas that have evolved, at least in part,

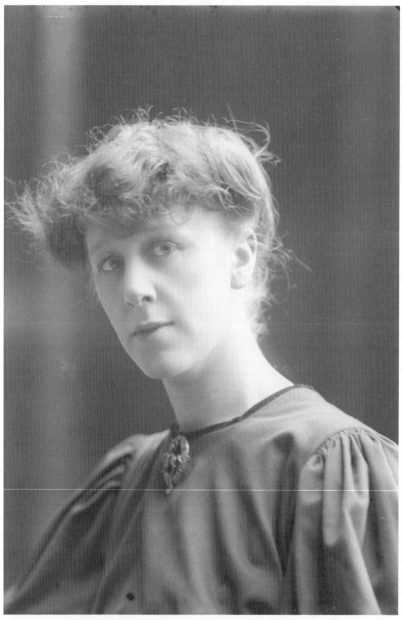

Figure 4.1. Portrait of Manda Björling, *Scenisk Konst*, Nr. 2, 1907, 3. Photograph by Atelier Jaeger. Courtesy of Swedish Performing Arts Agency.

for the purposes of discerning the intentions of others. These small examples demonstrate the various ways in which spectating, rather than a state of passive observation or objective appraisal, is a highly active embodied engagement within a series of "blends."

Reviews of the 1906 production capture these competing "blends," namely the established, embodied patterns of reception for readers of the eighteen-year-old play with the novel case experience of encountering an "actual" Miss Julie onstage. Both are embodied phenomena. When reading, generally, and especially while reading direct speech (such as dialogue in a play), most people hear an "inner reading voice" that, in many cases, may "blend" to become the voices of various characters.[13] We may also begin to visualize the characters and setting, which we typically call imagining; but this process may be more accurately described as deriving input spaces from the text that guide us in constructing conceptual blends for ourselves as we move through our reading, which we sustain over varying durations of time. When we get caught up in our reading, immersed in our blending, we experience emotions that, according to some cognitive theorists, dispose us toward taking actions; such actions, while not performed, nevertheless are psychologically real. We experience emotions (embodied responses) that prepare us for sex, violence, or to recoil in fear or disgust. We may also experience embodied simulations, such as Miss Julie taking up the razor, and other intentional gestures, via our so-called "mirror neuron" system.[14] This process of constructing and sustaining blends is our embodiment of the text as readers, and when we reread a text our blends may become more elaborate, but also become more established as patterns of feeling.

For example, before even discussing the performance of Björling as Miss Julie, one critic writes at length about the protagonist as a woman of "degenerate tendencies, which render her wholly a feminine beast," whom the playwright implausibly allows to "spew words of the wildest man-hatred," which apparently is contradicted by Julie's sexual encounter with Jean: "But at the same time she isn't even capable of refusing a valet, she loves all men, everyone, and to her sensibility there is no place for fury against any of them."[15]

Here I would like to address the embodied processes linked to voice perception in contrast with the aforementioned "inner reading voice" in order to examine the apparent schism for this reviewer between the blends they sustained in reading the play versus those they experienced in Björling's performance. In apparent contrast with their previous blended experience of a "degenerate" Miss Julie with an inclination "to spew words," this same critic observed that Björling "has also of course such a dulcet mild voice."[16] Research in voice perception has demonstrated that

"voices can also be thought of as 'auditory faces': like a face, each voice contains in its physical structure a wealth of information on the speaker's identity and affective state, that we are all able to perceive with often good accuracy."[17] Voices remain unique to us, even without linguistic content, because of a species-specific endowment to extract *paralinguistic* information in voices.[18] Using fMRI, it was shown that "voice-selective areas can be found bi-laterally along the upper bank of the superior temporal sulcus (STS). These regions showed greater neuronal activity when subjects listened passively to vocal sounds, whether speech or non-speech, than to non-vocal environmental sounds."[19] Thus, "the voice-selective areas in the STS may represent the counterpart of the face-selective areas in human visual cortex."[20] The effects of this embodied process seem to have moderated the critic's established blend of the character to allow engagement with the new blend provided in Manda Björling, including her "dulcet" voice, resulting in aesthetic appreciation of the actor and a newfound empathy toward the character: "She had captured the unfortunate Julie's haven and let her spirit enter into it. A gentle spirit, a conciliatory one. This Julie became a casualty, whom one pitied. She was not loathsome, as when I read her 18 years ago. She was a rotten branch on a noble tree."[21]

Another critic similarly had to reconcile a preestablished blend to the actuality of a performance: "*Miss Julie* is, in short, not a play. What in the reading is fleshed out by the imagination, becomes nothing but gaps in a stage performance. This nocturnal drama, played out on a Midsummer's Night and in which a count's daughter throws herself in the arms of her father's roguish valet is like a stepladder, where every rung is a particular emotion, yet highly dramatic, yet ridiculous."[22] For this same critic, a negotiation then takes place between these preestablished patterns of feeling, the novelty of seeing the role performed by an unfamiliar actor, and the aesthetic assessment of the performance, resulting in a reappraisal of the play itself: "Mrs. Linderoth-Björling, an entirely new acquaintance to Stockholm audiences, played Julie in a genuine manner, for the most part. . . . If she did not succeed yesterday in giving life to the occasional detail in the piece, is it much more likely the fault of the role rather than the actress."[23]

Significantly if not surprisingly, some reviews of Björling also reveal the primary emotion of lust that certain male critics apparently were accustomed to experiencing in reading the play, and which they wished to experience via Björling's performance, arguably in confirmation of their perceptions of the character and affirmation of their own desires. These critics frequently employ the word "blood" in some form to describe this sought-after desirability and its perceived lack in Björling/

Miss Julie; but they also acknowledge experiencing new, unexpected emotions. For example: "Miss Julie, the count's daughter with the aristocratic and criminal bloodlines, torn between social instincts and primitive desires, subdued and entrained to the limit of explosion, is played beautifully, to a degree, with harrowing veracity by Mrs. Linderoth-Björling. As the seductress, she did not succeed in conveying the vehement blood-heat, but in the anxiety and the deep soul-struggling despair, she found many true and moving expressions, and the final conflict became an artistic success."[24]

Further analysis of the spectator attunements to Björling's face, her intentional gestures, and empathetic perceptions of emotion would demonstrate how these derive, at least at base, from our cognitive endowments. But these endowments are, of course, still conditioned by cultural contexts and practices: "She had through her make-up given her beautiful Oscar Wilde face an exaggeration in its features, such as in ancient relatives becomes a genetic-marker, not beautiful but distinguished" (figure 4.2).[25] This image, taken in contrast with the prior portrait of Björling (figure 4.1), which conveys something of Björling's "beautiful Oscar Wilde face," evidences the "exaggeration" in makeup and "distinguished" attitude the critic describes; such a reconciliation is made possible through the embodied phenomenon of conceptual blending.[26]

Arguably the most significant consequence of the Stockholm premiere was the establishment of the Intimate Theatre, which opened in late November 1907, and where *Miss Julie* was ensconced as a cornerstone to that company's economic viability; 134 performances of the play were given over the next three years.[27] Though the Intimate Theatre closed in 1910, its production of *Miss Julie* with Björling in the title role continued to be performed on various stages and also entered a new medium. Shortly after the closing of the theatre, the first filmed adaptation of the play was directed by Anna Hofman-Uddgren (1868–1947). The film premiered at the Oriental Theater in Stockholm in January 1912 and starred Björling, Falck, and Karin Alexandersson (1878–1948). While no copy has survived, and although critical appraisals of the film varied, the film and the press coverage arguably served to amplify Björling's association with the role of Miss Julie to a broader audience.

This effort to popularize Strindberg in the new medium of film coincided with both his growing public acclamation and his declining health, which culminated in a very different, embodied reception of *Miss Julie* by a different sort of audience. Four months after the film premiere, Björling, Falck, and Alexandersson presented *Miss Julie* as part of a public homage to the dying playwright. This revival was performed on May 1, 1912, at the People's House Theatre in Stockholm and was well

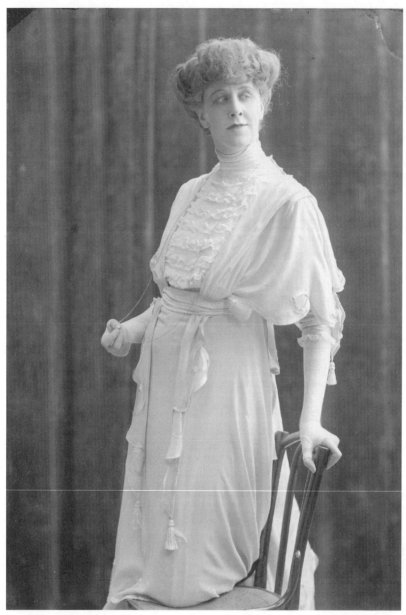

Figure 4.2. Manda Björling as Miss Julie at Folkteatern, Stockholm, 1906. Photograph by Atelier Jaeger. Courtesy of Swedish Performing Arts Agency.

received critically: "The roles remain, as one many times has had occasion to observe, excellent in each and every of the performances, so that this tragedy, gripping in itself, with its masterful dialogue, still worked even from the stage its old overwhelming effect."[28] But rather than the literary audience who frequented the 150-seat Intimate Theatre, the 700-seat People's House Theatre hosted a working class audience celebrating not only the "people's poet," as Strindberg was now called, but also International Worker's Day. This new audience became the subject of theatrical criticism: "I must admit that the most beautiful tribute—a scrap of understanding on the part of the public of the playwright's work—regrettably was absent. I have not had, for a long while, so painful an impression of a wholly unsympathetic auditorium. In vain one tried by hushing to put a stop to the cruelest inappropriate laughter. It was the first of May, and they wanted to laugh."[29]

Bruce McConachie has emphasized that "both sympathy and its opposite, antipathy, require conscious attribution and appraisal" and that "the mind/brain makes a judgment about another person's relative goodness before the spectator is aware of 'feeling against' . . . audiences side with or against actor/characters on the basis of their desires and interests in the world of the play."[30] A satirical cartoon appearing in a daily newspaper exhibits this phenomenon (figure 4.3). The caricature shows Miss Julie/Björling in tears with a representative trio of male spectators laughing in response; it was originally published with a caption: "Moreover 'the people' in The People's [House] Theatre celebrated their great poet by laughing at 'Miss Julie' and sending a laurel wreath."[31] McConachie points out that "social laughter, which spreads easily to others in every culture, tends to solidify friendships and build group solidarity."[32] What kinds of "solidarity" were being affirmed among the People's House audience?

The moment depicted in the caricature seems to derive from the action of the play following the sexual encounter between Julie and Jean, when Jean suggests that Julie provide him with money to open a hotel and she responds that she has no money of her own:

JEAN: Then you can forget the whole thing—
JULIE: And—
JEAN: Things will stay as they are.
JULIE: Do you think I'll stay under this roof as your easy lay? Do you think that I'll let people point their fingers at me; that I can look my father in the face after this? No! Take me away from here, from the shame and the dishonour!—Oh, what have I done? My God, my God! [*Weeps*]
JEAN: So that's your tune now, is it?—What you've done? The same as many another before you![33]

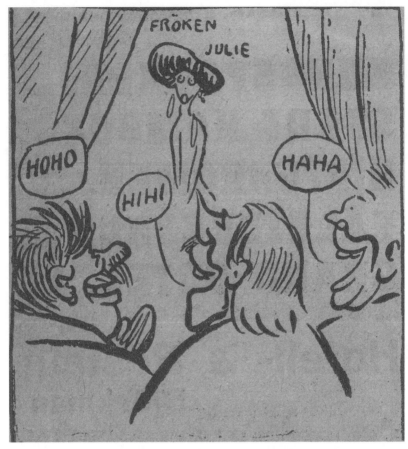

Figure 4.3. Manda Björling as Miss Julie at the People's House Theatre, Stockholm. *Dagens Nyheter*, May 2, 1912. Courtesy of Swedish Performing Arts Agency.

Laughter is the final step in a three-part process, the first phase a condition of being "unrelaxed, followed by a cognitive shift in which one realizes that the tension is unnecessary, leading to the third step of rapid relaxation-through-laughter.[34] The "People" attending to the performance of Julie, toward whom they were plausibly feeling both antipathy and sexual arousal, were also apparently experiencing tension (step 1) in this exchange, spurred by Jean's suggestion that the Count, Julie's father, might soon return; an authority figure and an input for both the actors/characters and the audience in the blend. Following Julie's appeal, "Oh, what have I done? My God, my God!" and her tears, it is Jean's line that

facilitated the recognition that the tension is unnecessary (step 2), leading to rapid relaxation-through-laughter (step 3). Furthermore, much of our emotional life is composed by so-called social or secondary emotions: humiliation, guilt, antipathy, sympathy, pride, shame, contempt, and embarrassment.[35] These are not as basic to survival as primary emotions but help us "to regulate and modify our social relationships," and may be sparked by either internal or external stimuli, leading to activation of dedicated neuronal networks, which then result in hormonal responses, increased blood flow to specific body parts, changes in muscle tone, and so on, all in preparation for action.[36] In this case, social emotions seem strongly in evidence. The People's House audience of working-class men seems to have relished the seduction and abandonment of the upper-class but "depraved" Miss Julie by Jean, their onstage representative. Thus a misogynistic "pride" is affirmed, as well the audience's conscious "antipathy" toward Björling/Julie; and there was also apparent disregard, or even contempt for the "hushing" by the literati. Finally, we might reasonably speculate that Björling experienced the social emotion of humiliation before this audience; but whether this informed her performance as Miss Julie cannot be reckoned, whether negatively, positively, or neutrally. In any case, the performance still exerted "its old overwhelming effect."

The criticisms of the People's House audience reveal a gap between those spectators who had an established set of responses (the "educated people" who attended the Intimate Theatre and for whom Strindberg originally intended his play)[37] with a new audience who, despite the objections of commentators, responded appropriately to the malicious humor that Jean employs. This is not to say that Julie's weeping is a mere device to lead to a joke. The "weeping" indicated in the stage directions is motivated by the same tension in the blend that also leads to the audience's laughter: the events transpiring onstage and also the danger that the Count will soon return. Finally, within the blend, Julie's tears are a cognitively viable means of managing the emotion of "panic."[38]

Regardless of the May Day travesty in 1912, Björling and Falck would continue to perform *Miss Julie* over the next twenty-five years, touring throughout Scandinavia, the Baltic countries, Russia, Italy, and other venues in Europe. Yet despite her decades of work as a preeminent interpreter of Strindberg, the accomplishments of Manda Björling in the role of Miss Julie are difficult to gauge. She gave no interviews, composed no autobiography, left no personal archive, and has been defined primarily by male writers, including her husband and collaborator, August Falck. At the outset of her career, Björling was criticized for being less than "full-blooded," that is, an object of desire, by male critics familiar with the script through reading and not with the play-in-performance;

for working-class men in 1912, Björling became an object of ridicule; fifteen years later, another generation of critics would regard her as still lacking in "full-bloodedness" and "hot-bloodedness."[39] Nevertheless, it is reasonable to assume that a significant portion of Björling's audiences were other women, given that the Intimate Theatre had separate salons to accommodate female and male spectators.[40] These audiences included some women journalists, as well as artists such as Anna Hofman-Uddgren who imported the Intimate Theatre cast for the first film version of *Miss Julie*; but their perspectives on Björling were largely eclipsed or, like the film, have been lost. Despite these gaps in testimony, and despite the sexist bias in much of the extant critical responses, review upon review attests to the cumulative effect of the play's ending, which was impossible to attain without Björling's embodied presence and her unique engagement in the blend of the role.

Björling's career as Miss Julie describes an arc of embodied performance over an exceptional duration of time, and through an impressive number of repetitions: at least 600 performances in all, and perhaps more.[41] And throughout her career as Miss Julie, Björling was still consistently recognized as a significant and individual artist: "It's possible that she in this did not fulfill the author's harshest intentions. So much the better. For the art of the actor art is of course the gift of reconciliation."[42]

While it is difficult to ascertain Manda Björling's approach to acting, it is possible to infer a primary emotion that could account for a career-long dedication to a particular role: "to seek."[43] And if the art of the actor is, rather, conceptual blending (a necessary prerequisite to interpretive "reconciliation"), and allowing that emotion is a disposition toward action, Björling's career then demonstrates a remarkable quest. This primary emotion is, in fact, evoked by Strindberg in the play's preface: "I find the joy of life in its cruel and powerful struggles, and my enjoyment comes from getting to know something, from learning something" (i.e., seeking).[44] It is evident that Björling was also motivated by this primary emotion, and continued to seek throughout her substantial career of performances, blends, and embodiments as Miss Julie.

Notes

1. I wish to acknowledge the indispensable assistance of the Swedish Performing Arts Agency, the Strindberg Museum, and the College of Arts, Letters, and Sciences at the University of Arkansas, Little Rock, in producing this research, and to offer my thanks to Marianne Seid, Camilla Larsson, and to Finn Afzelius.

2. Carl Plantinga, *Moving Viewers: American Film and the Spectator's Experience* (Berkeley: University of California Press, 2009), 54. For Plantinga, emo-

tion is "concern-based construal," an intentional mental state, accompanied by various kinds of "feelings, physiological arousal, and action tendencies."

3. Bruce McConachie, *Evolution, Cognition, and Performance* (Cambridge: Cambridge University Press, 2015), 44–49.

4. For a full account, see Sue Prideaux, *Strindberg: A Life* (New Haven, CT: Yale University Press, 2012), 1–23.

5. Gilles Fauconnier and Mark Turner, *The Way We Think: Conceptual Blending and the Mind's Hidden Complexities* (New York: Basic Books, 2002), 40–44.

6. August Strindberg, "Preface," *Miss Julie and Other Plays*, trans. Michael Robinson (New York: Oxford University Press, 1998), 60.

7. McConachie, *Evolution, Cognition, and Performance*, 134–42. "Living in the blend" (or "immersion"), along with emotional coupling and entrainment, are essential components in the Dynamic Systems Theory (DST) approach that McConachie has developed for performance analysis.

8. Egil Törnqvist and Barry Jacobs, *Strindberg's Miss Julie: A Play and Its Transpositions* (Norwich, UK: Norvik Press, 1988), 241–43.

9. René [Anna Branting], "Fröken Julie," *Scenisk Konst*, no. 2 (1907): 2. My translation.

10. —l—r, "Strindbergs 'Fröken Julie' på Folkteatern," *Stockholms Tidningen*, December, 1906, n.p., translation and emphasis mine. The bowdlerized pseudonym "—l—r" was the only identification provided by the publication for the author of this piece.

11. McConachie, *Evolution, Cognition, and Performance*, 109–11. Plantinga, *Moving Viewers*, 72–75. Transposing Plantinga's idea of "artifact emotions" in cinematic spectatorship, McConachie proposes the term "production emotions" to identify emotional responses to the technical features of a theatrical performance.

12. René, "Fröken Julie," 2, translation and emphasis mine.

13. Ben Alderson-Day, Marco Bernini, and Charles Fernyhough, "Unchartered Features and Dynamics of Reading: Voices, Characters, and Crossing of Experiences," *Consciousness and Cognition* 49 (2017): 99.

14. The Mirror Neuron System (MNS) is a theoretical model that has been much debated since the earliest research on "mirror neurons" in macaque monkeys was published by Vittorio Gallese, Giacomo Rizzolati, and others in the 1990s. While the existence of such a system in humans is hypothetical, there is substantial consensus that we experience some basic level of motor stimulation in response to observing goal-oriented, intentional gestures made by others. An effective consideration of the mirror neuron hypothesis may be found in Lisa Aziz-Zadeh and Richard B. Ivry, "The Human Mirror Neuron System and Embodied Representations," *Progress in Motor Control* (2009): 355–76, DOI 10.1007/978-0-387-77064-2_18; Springer Science + Business Media.

15. René, "Fröken Julie," 2, my translation.

16. Ibid.

17. Pascal Belin, Robert J. Zatorre, and Pierre Ahad, "Human Temporal-lobe Response to Vocal Sounds," *Cognitive Brain Research* 13 (2002): 17.

18. Pascal Belin, Shirley Fecteau, and Catherine Bédard, "Thinking the Voice: Neural Correlates of Voice Perception," *TRENDS in Cognitive Sciences* 8, no. 3 (March 2004): 129.

19. Pascal Belin, Robert J. Zatorre, Philippe Lafaille, Pierre Ahad, and Bruce Pike, "Voice-Selective Areas in Human Auditory Cortex," *Nature* 403 (January 20, 2000): 309.

20. Ibid., 309.

21. René, "Fröken Julie," 2, my translation.

22. —l—r, "Strindbergs 'Fröken Julie' på Folkteatern," my translation.

23. Ibid.

24. E. N—m, "Strindbergspremiär i Stockholm," my translation.

25. René, "Fröken Julie," 2, my translation.

26. The director, August Falck, attributed this photo to a passage in the play that specifically entailed issues of aristocracy and rank, when Miss Julie provocatively suggests to Jean that he is an aristocrat and that she herself is in descent: "'I step down." August Falck, *Fem år med Strindberg* (Stockholm: Wahlström & Widstrand, 1935), 177; August Strindberg, "Miss Julie," *Miss Julie and Other Plays*, trans. Michael Robinson (New York: Oxford University Press, 1998), 79.

27. Törnqvist and Jacobs, *Strindberg's Miss Julie*, 243.

28. Ths, "Strindbergs 'Fröken Julie,'" unknown pub., [ca. May 1, 1912], n.p., my translation. This was the first of eleven performances of the play at the People's House Theatre.

29. B. B—n, "På Folkets hus teater," unknown pub., [ca. May 1, 1912], n.p., my translation. As in the previously cited *Stockholms Tidningen* article, the only author name provided for this article was this bowdlerized pseudonym.

30. Bruce McConachie, *Engaging Audiences: A Cognitive Approach to Spectating in the Theatre* (New York: Palgrave Macmillan, 2008), 100.

31. *Dagens Nyheter*, May 2, 1912, my translation.

32. McConachie, *Engaging Audiences*, 106.

33. August Strindberg, *Miss Julie*, in *Miss Julie, and Other Plays*, trans. Michael Robinson (New York: Oxford University Press, 1998), 89.

34. McConachie, *Engaging Audiences*, 107.

35. Antonio R. Damasio, *The Feeling of What Happens: Body and Emotion in the Making of Consciousness* (New York: Harcourt, Brace & Co., 1999), 51.

36. McConachie, *Evolution, Cognition, and Performance*, 105.

37. "If we had a *small* stage and a *small* auditorium, then perhaps a new drama might arise, and the theatre would at least be a place where educated people might once again enjoy themselves." Strindberg, "Preface," 67–68, original emphasis.

38. Cf. McConachie, *Engaging Audiences*, 111.

39. M. S., "Manda Björling och August Falck i 'Fröken Julie,'" *Stockholms Dagblad*, December 1, 1927, n.p.; E. W. O., "'Fröken Julie'—Strindbergsspelens tredje program," December 1, 1927 *Svenska Dagbladet*, n.p., my translations.

40. Falck, *Fem år med Strindberg*, 54.

41. Falck, *Fem år med Strindberg*, 19. Cf. "Ett märkligt jubileum. Manda Björling och August Falck i Fröken Julie," *Svenska Dagbladet*, December 12, 1931; in

this interview, Falck offers a higher estimate of 1,000 performances of *Miss Julie* with Björling in the title role.

42. René, "Fröken Julie," 3, my translation.

43. McConachie, *Evolution, Cognition, and Performance*, 104–5. Jaak Panskepp identifies seven distinct neurobiological *emotion systems*: seek, fear, rage, panic/ grief, lust, care, and play.

44. Strindberg, "Preface," 57–58.

Hidden Damage

When Uninformed Casting and Actor Training Disregard the Effect of Character Embodiment on Students of Color

Kaja Amado Dunn

Civil rights work and social justice work take imagination, to imagine a world that isn't there, and you imagine that it can be there. And that's the same thing that you do whenever you imagine and insert yourself in a future space, or in a space where you've been absent.
—Ava DuVernay, *New York Times*, March 1, 2018.

THIS ESSAY LOOKS AT THE practices and effects on the bodies of theatre students of color with respect to uninformed training and casting choices. It examines a way to make a "safe space" for students of color to train in a way that is both culturally and professionally relevant, as well as ways to open up programs to better train and equip all students to navigate race on stage. Building and expanding on such texts as *Black Acting Methods* and *No Safe Spaces*,[1] it will also explore the ways Critical Race Theory (CRT) can be utilized in the classroom, teaching laboratory and studio, and classroom laboratory and performance space to more effectively teach acting in a culturally relevant way, both when dealing with bodies of color performing traditionally European texts as well as when incorporating work by writers of color. Race, while it includes cultural elements, is essentially rooted in physical embodied characteristics.

I was trained as an actor in three separate conservatories in urban areas (high school in a university program, then a BFA and an MFA) by over twenty-five instructors and professors. I had very few female professors. I never had an instructor of color. Ever. As a young black woman searching for a way into the field, this left me adrift. I was trained in Stanislavsky and then Meisner. I did the character-building exercises, got in touch

with my body in voice and movement, then was repeatedly and explicitly instructed to ignore or change that body.

My understanding of racial identity, of the body in which I lived, was consistently being filtered through the lens of the white gaze of my instructors. Though I learned much and have a great respect for many of these teachers, the training system I came through and now find myself teaching in was designed for white students with a white canon. Bodies of color onstage, especially those that did not fit neatly into preconceived racial notions, had to be altered, conformed to existing stereotypes, or more often ignored altogether with the concept of "colorblindness." Claire Zhuang, in "A Parting Letter to My MFA Program," expresses the immense frustration experienced by students of color: "Theatre has never been a safe place for me. . . . If institutions across the nation are teaching students unexamined sets of assumptions about what American theatre has been, is, and can be . . . I see no place for myself in theatre because theatre as an institution (which I think it often forgets it is one) has not identified a way to properly engage and understand itself as a locus of domination; as a location that also perpetuates and upholds white supremacist values."[2] Zhuang is highlighting the repercussions for students of a training system that refuses to acknowledge the impact of white privilege, and the assumption of the white body and culture as the universal standard in its development. In these institutional settings, bodies of color become displaced or must imitate a type of white incarnation and self-erasure.

In my own training, I repeatedly ran into the problems of mandatory self-erasure and negative stereotyping; I was repeatedly placed in the position of altering or disappearing my body, or of placing that body in the position of conforming to an unacknowledged racial hegemony. In conservatory, I was repeatedly told while working on a scene of a young girl in the 1950s to apply Meisner technique to everything except my race (in a scene written for a white actor); my (white male) instructor casually told me to ignore my race and just do the assignment. On another occasion, in my first college acting class, while other (white) students were assigned scenes from *The Heidi Chronicles* or *Laughter on the 23rd Floor* (lighthearted, straightforward, semicomic texts with wholesome characters), a Filipino man and I were assigned a scene where we were to appear in our underwear in a rough sexual encounter; in the next assignment I was a prostitute, and then a maid. When I finally approached my instructor, I was told he "was trying to get me used to the parts I could expect to play." So while other students were slowly working through straightforward character texts, I was left grappling with the literal embodiment of damaging stereotypes. As a young actor who was still try-

ing to figure out where I fit into the art, playing these embodiments of negative stereotypes left me struggling to find the space my body fit into and searching for my place in the art form.

Countless versions of this experience are told by actors all over the profession, continuing past the training lab, including in the story told by Broadway actress Carolyn Stephanie Clay in a *Washington Post* article titled "Black Actresses Still Have to Play Maids on Broadway. How Do They Feel About It?" In the 2017 revival of Lillian Hellman's *The Little Foxes*, Clay was playing the role of Addie, a servant, in a production that received rave reviews because of the work of celebrity actresses Laura Linney and Cynthia Nixon, who were role-swapping the leads of Regina and her sister-in-law Birdie. Addie and the butler Cal are the only two roles in the play written for black actors, and both are written as stereotypes complete with dialect; Addie is a Mammy character, while Cal is an Uncle Tom. While this production made an effort to alleviate some of the issues presented by the text with regard to these characters—for example, ensuring Addie was seen to be literate—Clay's body was still positioned as the stereotyped servant to the white characters onstage. These damaging uses of bodies of color continue to remain unexamined even at the highest levels of theatre and criticism: the revival's *New York Times* review fails to mention Clay's character or performance, although it details the virtuosity of the two white actresses in standout roles.[3]

For Clay, as an educator, this role presented the challenge that also comes with being an instructor of color in a system that still prizes and foremost is structured around the dominant culture. Her role as a servant was not even worthy of a mention in the original review because she was in service to two white actresses with outstanding roles. As an educator she didn't want to propagate stereotypes, even as she and her director worked against them in the confines of the script. At the end of the day her students would still see a black body in servitude to white ones, as the *Post* article points out: "Neither, tellingly, did Clay have a desire for two of her former Ellington students, now studying drama in Manhattan at Juilliard, to see her as Addie. 'I don't want the next generation to have to continue to grapple with these roles,' she says. 'It's not about being ashamed. It's about having the opportunity to aspire to being their highest selves, in material that's worthy of their experiences.'"[4] So, structurally, we as theatre training institutions need to create more platforms for bodies of color to achieve their "highest selves"; however, too many institutions continue to fail their students of color on this issue.

This is at least in part because in the United States in 2015, according to the US Department of Education, seventy-seven percent of full-time faculty members and eighty-three percent of full professors were white.[5]

Sit with that for a moment. What does it mean when faculties have no diversity of representation? It is a problem not just for the students of color but also for white students, who may miss out on the experience of different perspectives and aesthetics. Theatre teachers of color have usually developed skill sets and tactics for navigating a system that was not designed for them. When students fail to see a reflection of diversity on faculty, even as some faculty engage in diverse work, it sends a message that this is not a space where diversity as an authoritative presence is present and perhaps not a place where a diverse group of teachers belongs. In addition, a revered theatre canon comprising scripts that feature uninterrogated racial stereotypes and/or painful historical roles for students of color (still largely featuring the work of deceased, white, male authors) creates a complex web for students of color to navigate. Students of color in traditional actor-training programs may have limited access to performing culturally specific roles outside these entrenched historical parameters.

This is damaging for many reasons. The actor's body and representation are utilized for employment after training. In some fields, a student's cultural background affects their perspective but not their day-to-day work. In acting, however, it is the student's physical body that is engaged in the work at hand. Due to common Eurocentric teaching practices, students of color do not often get to perform specific embodiment in the classroom, so they must learn the dialects, types, and even tropes of the Black Diaspora or their specific culture outside the acting classroom. This means that they often learn on the job and are deprived of the specific feedback from both instructors and classmates that other students get to take advantage of. There are techniques and styles that are very culturally specific that young actors of color in our increasingly global world may not be equipped with. The overwhelming proportion of acting instructors are Caucasian, and many were trained in the era of "colorblind casting" and have a limited cannon for students of color.

A physical and cognitive dissonance occurs when nonwhite students are taught about "universal" theatre truths and "universal" stories. Universal most often equals white-Eurocentric. As Luckett and Shaffer point out in *Black Acting Methods*, "White-ness overtly and covertly pervades the texts and linguistic structures, and those who do not share a white lineage or hue are de-centered, misaligned and exiled from a theatre history that they rightfully co-constructed."[6] From courses in the history and origins of theatre, to the texts considered standard, to more diverse texts and styles being relegated to "special course offerings," students of color in theatre training programs often get the message right away that being a successful acting student will involve disappearing themselves,

their experiences, their speech and culture, to become a "better trained" actor. Critical developments in modern theatre, such as the work of visionary Dr. Barbara Ann Teer, Lalo Astol, Luis Valdez, the contributions of Mako and East West Players, and the origins of the circle formation, are overlooked while we focus on Edward Albee, Tennessee Williams, and the medieval passion play.

If you doubt this truth, just ask yourself when the last time was that you heard of "White History," "White Theatre," or "White Literature" as university courses. In an early 2018 *Guardian* article titled "What Is White Culture, Exactly?" Mona Chalabi took on the issue: "If whiteness takes no shape, then the concrete structures that shaped it (and often benefit from it) remain invisible too—If white culture remains vague, then it can lay claim to every recipe, every garment, and every idea that is not explicitly 'non-white.' That would mean that my identity is just a sum, that my 'non-whiteness' can only be understood as a subtraction from the totality of 'whiteness.' I refuse to be a remainder."[7] Chalabi is explaining the phenomenon of white culture being "undefined" and seen as standard, while everything else is othered and specific. If we were to acknowledge how much of the canon that we use in our curriculum embodies whiteness we would be forced to face the fact that the system was designed for and propagates whiteness and minimizes bodies of color. In their paper "Reimagining Critical Race Theory in Education: Mental Health, Healing, and the Pathway to Liberatory Praxis," Ebony McGee and David Stovall write: "Applying CRT in education makes it possible to analyze practices and ideologies through a race conscious lens, which can help to frame critical questions addressing the traumas that directly affect communities of color. As insurgent scholarship rooted in critique and action, CRT 'seeks to inform theory, research, pedagogy, curriculum and policy.'"[8] The practice of using CRT to understand the damage of uninformed training requires a shift in some of the standard training and institutional practices. While CRT has a history of being used in the fields of sociology, history, and general education, its application to theatre training is underutilized.

Looking at the principles of CRT as developed by Daniel Solórzano and Tara Yosso, we examine "the intercentricity of race and racism." Race and racism are not monolithic concepts but complex, dynamic, and malleable social constructions endemic to life in the United States. Due to their shifting contexts, definitions of race can include and exclude particular groups, depending on the historical moment. CRT challenges the dominant ideology around students of color: the master narrative on African American and Latino/a students in education is engulfed in deficit theories (and dialogue).[9] For theatre educators this means in the class-

room we must begin to look at the ability to teach diverse bodies in a culturally competent way as an asset for both ourselves and our students.

CRT also helps us to shape both our curriculum and the material we choose. There is an emphasis on social justice. CRT offers itself as a theoretical and methodological paradigm aimed at the examination and elimination of race, class, and gender oppression.[10] This way of thinking is evident in the texts of many authors of color, and usually resonates in the way students of color embody the work that relates directly to them. CRT also helps us empower the students to embody their known culture and experience, since a core tenant is the "Centrality of experiential knowledge": The knowledge people of color acquire in the fight against hegemonic forces in education is legitimate, valid, and necessary for creating spaces where they can engage.[11] In other words, CRT helps empower students within the classroom to take ownership of the experience they have traveled in their bodies, and to become co-authorities in the embodiment of character. It marks their experiences as valuable and central to their training.

The problem with the Eurocentrism-as-universality approach manifests in voice and speech classes, where a survey of syllabi will show many black students are taught dialects they will never be asked to use professionally, but instructors ignore dialects they may need all the time (for example, it is standard to learn an Irish and a Midwestern dialect while Caribbean, South African Black and Colored, Hindi, and Chinese are regulated to the "special project" section of the course where students teach themselves). Students may be insulted and shamed for their dialect or asked to put on a stereotyped dialect an instructor assumes they should have.

When we train acting students, acting instructors teach them to "be truthful in imaginary circumstances" and to "live in their bodies"; we ask them to study the given circumstances of a play including the characters' social and historical background. However, in cases of students of color, students may be told implicitly or explicitly to ignore their cultural background for the sake of "color-blind casting" or scene assignments. In the chapter "Seeing Shakespeare Through Brown Eyes" in *Black Acting Methods*, Justin Emeka describes "a mask used to hide or minimize any ethnic flavor the actor naturally possessed . . . shaped by comments or notes from the director that never mentioned race specifically (but commented on speech, gait, laughter, and singing)." Ultimately Emeka recalls needing to use jokes and laughter on breaks as "an armor against our uncertainty as we wore masks onstage to fit into a world that was ultimately incapable of recognizing our full existence."[12] This included the way the actors moved and sounded as they embodied the text. Essentially, Emeka is describing a type of tokenism where actors of color

are used to add visual "flavor," but any embodiment of their uniqueness is disappeared from the production.

In her book *No Safe Spaces: Recasting Race, Ethnicity, and Nationality in American Theatre*, Angela Pao breaks down subcategories of nontraditional casting (a term that carries its own problems, because "traditional casting" alludes to the idea of the normative and standard, othering culturally specific practices as exceptional). The subcategories identified by Pao include:

1. "Color-blind casting. Actors are cast without regard to their race or ethnicity; the best actor is cast in the role."

An example of this would be Emeka's casting in the ensemble of *Our Town*. This is often the type of casting most present in theatre training programs and what many instructors still think of as a solution to the problem of cultural inclusion.

2. "Societal casting. Ethnic, female, or disabled actors are cast in roles they perform in society as a whole."

Clay's role as Addie in *The Little Foxes* is a type of societal casting. This can sometimes occur subconsciously and cause damage as students of color are put in the position of embodying stereotypes (for example, the black actress playing Medea can further the notion of an "angry black woman").

3. "Conceptual casting. An ethnic, female, or disabled actor is cast in a role to give the play greater resonance."

We commonly see this in a play like *Romeo and Juliet* where the leads are from two different cultural groups.

4. "Cross-cultural casting. The entire world of a play is translated to a different cultural setting."

The Broadway revival of *Cat on a Hot Tin Roof* cast with black actors is an example of this.[13]

This is the experience that theatre students of color, and often their teachers, grapple with. How do they maintain the dignity of characters that are seen through a dated or stereotyped lens within the given circumstances of the play so that we can keep telling these "classic stories" in our canon or work with a new hot contemporary play that may be loved by white audiences and critics but gives communities of color pause and has us discussing its problems among ourselves? What does it do to a student to repeatedly play the subservient or victimized character to her white classmates in culturally specific roles or be forced to erase his entire cultural experience in the service of being color-blind cast in a role

and asked to embody whiteness? What does a person in the vulnerable position of student do when they are dealing with a professor and/or director who consider themselves "woke" and liberal but who are repeatedly making harmful or racially insensitive directing choices in a theatre lab? What does this kind of repeated stress do to a student? What is to be done to reclaim the acting classroom as an effective learning space in which all students can flourish by playing bodies with cultural specificity?

In the past, "acts of inclusion were perceived simply as extending the educational opportunities enjoyed by majority white men to others. Now we know that education is a two-way exchange that benefits all who participate in the multicultural marketplace of ideas and perspectives. This new vision has supplanted an idea of education in which disciplinary and cultural experts transmit their privileged views to others."[14] But this new dynamic has not necessarily been applied to actor training programs.

Currently, the students of any one ethnic group (East Asian, Black Diaspora, and South Asian) often appear in a theatre program as a cultural monolith. Since there is a lack of diversity and, in some cases, cultural competency on faculties, these students, by virtue of their pigmentation or facial features, are not only presumed to know their own cultural history, but also to be poised to turn an informed and critical lens on it.

Another way in which these types of training and casting are damaging to students is the overall effect on their health. In an NPR report last year titled "Racism Is Literally Bad for Your Health," Harvard University professor David Williams explained, "Basically what we have found is that discrimination is a type of stressful life experience that has negative effects on health similar to other kinds of stressful experiences."[15] College students exposed to overt racism as well as intended and unintended micro-aggressions experienced a rise in cortisol levels, increased depression, and other effects including an increase of coronary artery disease.

The physical costs of racism were articulated by Martinican psychiatrist Frantz Fanon: "I subjected myself to an objective examination, I discovered my blackness, my ethnic characteristics; and I was battered down by tom-toms, cannibalism, intellectual deficiency, fetishism, racial defects, slave-ships, and above all else, above all: 'Sho good eatin.'"[16] Though Fanon wrote this in 1952, one need only read reports of multiracial plays gone awry on college campuses to understand its current relevance. In his essay Fanon discusses how the black body must not only come into its own understanding but how in America it must learn to understand the white perception of itself and the pain and damage this causes. For students of color this means the extra burden of determining who you are as an artist and then figuring out your instructors' cultural competence to understand how they perceive you, and you must do this for the ma-

jority of interactions in your training. Not only is this a distraction from acting training, it can be exhausting and demoralizing.

In light of this, there are necessary—albeit hard—questions that must be asked, including: What types of plays and narrative styles are being used in directing and acting classes? What methods of addressing faculty do students of color have? What protections do they have when they bring up concerns? How much dramatic history and literature focused on nonwhite authors and theatrical traditions outside of Hansberry and Wilson are students of color being taught? Is the faculty using only deficit dialogue when talking about students of color, including "underserved," "underrepresented," "economically disadvantaged"?

In the acting classroom there are a whole host of major and minor changes that can lead to a more culturally competent acting pedagogy. To start, what texts are being used for in-class examples and performance assignments? Are Caryl Phillips, Louis Alfaro, Naomi Iizuka, Debbie Tucker Green, David Henry Hwang, Fernada Coppel, Dominique Morisseau, and Katori Hall finding their way in? One way to encourage a diversity of scripts is by pulling from what is being done professionally in the last few seasons in theatre houses known for producing diverse work (such as New York's Playwrights Horizons, Bush Theatre in London, Moxie Theatre in San Diego, or Hattiloo in Memphis). Not only will one get a more diverse range of voices than were taught in theatre classrooms twenty years ago, but one's students will have an edge on what is being done professionally because these theatres not only promote diverse work but end up being indicators of what larger houses will do in three to five years. In my class, if we are doing two scenes, one will be cast "inclusively" (these are scenes that can truly be done across cultures—think *Proof*, *The Wolves*, and *Archipelago*), while the other will be specific to the student's culture, race, or ethnicity. I find scenes by pulling modern plays from places like the Kilroys list, which publishes plays written by women and whose 2017 list includes "the 37 most recommended un- and underproduced new plays by female and trans authors of color."[17] Through sources such as these, every year I am able to find parts that are really open-ethnicity, not Eurocentric characters that can be cast with people of color. Examples include plays like *The Profane* (which calls for the actors to be cast "in any ethnicity in which a Muslim majority country exists")[18] or *The Curious Case of Watson Intelligence*. Talk about open culturally specific casting! I get really excited when I can cast scenes with roles specific to the student and reflective of what they might play, not just ethnically but also to type. This approach takes a lot more work than if I just had standard scenes. I am continually scouring theatre websites and bothering friends and colleagues for new scripts. This work allows my class to

see how each student's embodiment of the role can drastically change it. Teaching in this way allows students to see the assets their body brings to the canon of theatre. It reinforces that the work is about showing up and being present in one's body instead of disappearing one's self. The second way we can begin transforming the acting classroom is by using a multicultural pedagogy. For example, the integration of black acting techniques (the ones that we are not already using, like circling up)— call-and-response, check-ins, greater use of the circle formation, incorporation of hip-hop theatre,[19] and even the "Africanizing of Shakespeare" that Justin Emeka describes—allows for a more open and I think more effective classroom in many ways. First, black acting techniques reinforce the idea of community, instead of the more colonialist method where the teacher brings all the knowledge and students sit quietly and listen. In addition, using a variety of cultural techniques teaches students how to work in a broad range of ways and across styles. Directors they will encounter come to the work in a variety of ways, and if their bodies have been trained to respond to only one technique, students may struggle in the professional world.

Another thing that needs to change is the way in which we frame these discussions. Faculty should not speak of what isn't being done and how to "help people of color." Instead we can look at the benefits to all students of a more culturally competent dialogue.[20] Instead of only looking at the challenges students of color may face, we can start to expose the benefits of their inclusion. For example, we can discuss the economic viability of a diverse BFA class, the employability of such students. There is also a benefit to all students from the unique perspectives that diverse student bodies bring to the classroom and the variety of plays it allows your class to perform.

It is critical that race is not washed over in the classroom. Students should be encouraged to incorporate themselves into each of their characters and be offered the tools to do this. Theatre instructors must be willing to name and point out white culture and its prevalence in the acting classroom and beyond. It is well known among actors that if race is not listed in a casting breakdown, it means white unless there is a specific notice for ethnicity or an "open ethnicity call."[21] When white students are exposed to playwrights of color, their world of possibility opens as well. These playwrights also tend to write in styles and broader narratives; by not marginalizing work by people of color (or preaching to the choir by educating just those students who seek the work out), we educate a new generation of theatre makers, film producers, writers, and playwrights who can see a world beyond their lived experience. Why is theatre important? The stories we tell define ourselves and our national

and cultural identities. Theatre tells us how we see our own bodies and how to see the bodies of others, and how we see our societies. Students need to see a multiracial perspective. Educating all students in decolonized multiracial and cultural theatre and acting methods leads the way for educational and industry transformation and gives our students the education they deserve.

Notes

Epigraph from Melena Ryzik, "Ava DuVernay's Fiercely Feminine Vision for 'A Wrinkle in Time,'" *New York Times*, March 1, 2018, https://www.newyorktimes.com/2018/03/01/movies/a-wrinkle-in-time-ava-duvernay-disney.html, accessed April 2, 2018.

1. Sharrell D. Luckett and Tia M. Shaffer, *Black Acting Methods: Critical Approaches* (Abingdon, Oxon: Routledge, 2017), Angela C. Pao, *No Safe Spaces: Recasting Race, Ethnicity, and Nationality in American Theater* (Ann Arbor: University of Michigan Press, 2010).

2. Claire Zhuang, "A Parting Letter to My MFA Program," *Ethos*, June 6, 2017, http://www.ethosreview.org/intellectual-spaces/a-parting-letter-to-my-mfa-program/, accessed July 1, 2018.

3. Alexis Soloski, "Review: Laura Linney and Cynthia Nixon, Swapping Parts in 'The Little Foxes,'" *New York Times*, April 19, 2017, https://www.nytimes.com/2017/04/19/theater/little-foxes-review-cynthia-nixon-laura-linney.html, accessed July 27, 2018.

4. Peter Marks, "Black Actresses Still Have to Play Maids on Broadway. How Do They Feel About It?," *Washington Post*, June 29, 2017, https://www.washingtonpost.com/entertainment/theater_danc/black-actresses-still-have-to-play-maids-on-broadway-how-do-they-feel-about-it/2017/06/29/60311162-5a8f-11e7-8e2f-ef43171f6bd_story.html?utm_term=.2b7aeedbe38b, accessed July 27, 2018.

5. "Characteristics of Postsecondary Faculty," U.S. Department of Education National Center for Education Statistics, https://nces.ed.gov/programs/coe/indicator_csc.asp, accessed July 27, 2018.

6. Luckett and Shaffer, *Black Acting Methods*, n.p.

7. Mona Chalabi, "What Is White Culture, Exactly? Here's What the Stats Say," *The Guardian*, February 26, 2018, https://www.theguardian.com/world/2018/feb/26/white-culture-statistics-vegetables-alcohol, accessed July 27, 2018.

8. Ebony O. Mcgee and David Stovall, "Reimagining Critical Race Theory in Education: Mental Health, Healing, and the Pathway to Liberatory Praxis," *Educational Theory* 65, no.5 (2015): 491–511, doi: 10.1111/edth.12129.

9. Daniel G. Solórzano and Tara J. Yosso, "Critical Race Methodology: Counter-Storytelling as an Analytical Framework for Education Research," *Qualitative Inquiry* 8, no.1 (2002): 23–44.

10. Ibid.

11. Ibid.

12. Justin Emeka, "Seeing Shakespeare through Brown Eyes," in *Black Act-*

ing Methods: Critical Approaches, ed. Sharrell D. Luckett and Tia M. Shaffer, n.p. (Abingdon, UK: Routledge, 2017).

13. Pao, *No Safe Spaces*, 4.

14. Jonathan R. Alger, Jorge Chapa, Roxane Harvey Gudeman, Patricia Marin, Geoffrey Maruyama, Jeffrey F. Milem, José F. Moreno, and Deborah J. Wildes, *Does Diversity Make a Difference? Three Research Studies on Diversity in College Classrooms* (Washington, DC: American Council on Education and American Association of University Professors, 2000), 5, https://www.aaup.org/NR /rdonlyres/F1A2B22A-EAE2–4D31–9F68–6F235129917E/0/2000_diversity _report.pdf, accessed July 27, 2018.

15. David Williams, interview with Michel Martin, "Racism Is Literally Bad for Your Health," National Public Radio, October 28, 2017, www.npr .org/2017/10/28/560444290/racism-is-literally-bad-for-your-health, accessed July 27, 2018.

16. Frantz Fanon, "The Fact of Blackness," trans. Charles Lam Markmann, in *Theories of Race and Racism, A Reader*, ed. Les Back and John Solomos (London: Routledge, 2009), 259.

17. "The List 2017: The Top 9%," The Kilroys, June 23, 2017, https://thekilroys .org/list-2017/, accessed July 27, 2018.

18. Zayd Dohrn, *The Profane* (New York: Dramatists Play Service, 2017), n.p.

19. Luckett and Shaffer, *Black Acting Methods*.

20. Donna Y. Ford and Tarek C. Grantham, "Providing Access for Culturally Diverse Gifted Students: From Deficit to Dynamic Thinking," *Theory into Practice* 42, no. 3 (2003): 217–25, https://muse.jhu.edu/, accessed July 27, 2018.

21. Jazmine Harper-Davis, "Hamilton Casting Call, Or, The Making of Magical White Tears of 2016 & All That Followed," *Broadway Black*, April 1, 2016, http://broadwayblack.com/hamilton-casting-call-or-the-making-of -magical-white-tears-of-2016-all-that-followed/, accessed July 5, 2018.

Ecologies of Experience

John Dewey, Distributed Cognition, and the Cultural-Cognitive Ecosystem of Theatre-Training Settings

Cohen Ambrose

IN THE FINAL REMARKS of one of his last writings on education, delivered for the 1938 Kappa Delta Pi Lecture Series, philosopher and psychologist John Dewey argued that personal experience ought to be the ultimate goal and means of education: "Education in order to accomplish its ends both for the individual learner and for society, must be based upon experience—which is always the actual life-experience of some individual. . . . It is for this reason alone that I have emphasized the need for a sound philosophy of experience."[1] As an early-career faculty member and coordinator of a small theatre program at a teaching- and student-centered college, I was drawn to Dewey's assertion that the driving force of education is to create experiences that lead to more educative experiences. I was curious, then: since collaboration; studio training; theoretical, literary, and historical examination; and preparation all tend to culminate in the highly experiential process of production in most theatre-training settings, are we not perfectly positioned to attempt to articulate such a philosophy of experience? Since theatre training is also a deeply embodied experience, I argue for a philosophy that focuses its attention on the bodies of the teachers and learners at its core.

In this essay, I focus primarily on hypothesizing a scientific and philosophical basis for the conception of experience in order to inform future detailed and concrete outlines of educative experiences in the theatre-training setting. Dewey argues, "The more definitely and sincerely it is held that education is a development within, by, and for experience, the more important it is that there shall be clear conceptions of what experience is."[2] I suggest that current hypotheses of situated cognition—namely extended mind, as proposed by Andy Clark and David Chalmers,[3]

embodied cognition, and, primarily, distributed cognition—are in and of themselves examples of "what experience is." I also articulate some concrete examples of what the centrality of the bodies of the learners and teachers in a given training ecology might look like at curricular, institutional, and classroom and studio levels. These modes of considering a learner's brain-to-body-to-world engagement culminate in a metaphorical conception of the sociocultural and physical design of any human environment, including the theatre-training setting, that Edwin Hutchins calls a "cognitive ecosystem," or "cognitive ecology."[4]

For John Sutton and Evelyn Tribble, cognitive ecologies are "multidimensional contexts in which we remember, feel, think, sense, communicate, imagine, and act, often collaboratively, on the fly, and in rich, ongoing interaction with our environments."[5] The science community's relatively recent acknowledgment of cognitive ecosystems makes the literal and metaphoric ways of understanding the possibilities of change in theatre-training settings particularly ripe for exploration. Hutchins beckons: "As an object of study, this cognitive ecosystem falls into the cracks among the academic disciplines as they are currently organized. Because no field or discipline has yet taken ownership of cultural-cognitive ecosystems, little is known about their function."[6] Answering Hutchins's call, I suggest that theatre practitioners serving as teachers and leaders in institutions of higher education take ownership of cultural-cognitive ecosystems to help us form a theoretical and practice-based philosophy of embodied experience in the theatre-training setting.

The Conditions for Experience in the Theatre-Training Setting

In fairly clear terms, Dewey articulates what does and does not constitute an educative experience. Put simply, he argues that any experience that leads to new experiences is educative because it plants a seed for another experience. Whether the embodied experiences within the cognitive ecosystem themselves—an acting class, a run crew position, or an audition, for example—are negative or positive, if they do not cohere and lead to the germination and growth of further, generative experiences, they end up standing alone as mere isolated events that do not fit into a whole. Dewey warns that "each experience may be lively, vivid, and 'interesting', and yet their disconnectedness may artificially generate dispersive, disintegrated, centrifugal habits."[7] No matter how positive a given learning experience is for a student in one context, if it does not directly guide them into the next experience, it only leads to the dispersion and disintegration of their learning. At a curricular level, a theatre-training

program ought to prioritize the scaffolding of embodied experience so that each learning experience seamlessly flows into the next.

For Dewey, educative experiences are as close to life experiences as possible; that is, they first comprise qualities, those immediate, prereflective *things* of life, directly possessed; then situations, the amalgam of still prereflective constituent qualities of experience; also the analysis of qualities and situations, which comes after the moment of the *having* of quality; and finally habit, the predetermined means by and context in which the analysis of the qualities and situation occur. These cyclically occurring stages—qualities, situation, analysis, and habit—of experience are requisite to the fulfillment and completion of aesthetic and life experience. For example, rather than offering distinct three-credit courses, themselves each offering a distinct embodied experience in Acting, Voice, or Theatre History, for example, I envision a training course or module that is scaffolded with this embodied experiential structure Dewey describes: a block-scheduled, team-taught course or module designed around a conceptualization, rehearsal, and performance process of a theatrical production that consciously cycles through the constituent parts of experience (qualities, situations, and habits).

For Dewey, education is not necessarily or solely based on the transmission of knowledge because "to know" is not how we experience the world in a given situation, at least not at first. Qualities, as Dewey puts it, "in their immediacy are unknown and unknowable, not because they are remote . . . but because knowledge has no concern with them."[8] Knowledge, rather, is concerned with *how* things, or qualities, are arranged and ordered in an effort to contextualize them: "Immediate things may be pointed to by words, but not described or defined. Description when it occurs is but a part of a circuitous method of pointing or denoting; index to a starting point and road which if taken may lead to a direct and ineffable presence."[9]

In my teaching, this direct but ineffable presence of the object of study is where I often begin. For example, when teaching my script analysis course, I encourage students to simply point at (index) the play or story as if it were an object upon which they had never before stumbled. "Poke it, prod it, feel and study it," I tell them. "What are its qualities? Perhaps that will tell us something about what it's doing and why it's there." The students have to imagine the play or story *as if* it were literally a foreign object to be examined; in other words, they have to give it a body. They make a list of its qualities: "dank," "stuffy," "coarse," "split," "blistered," "unsanitary," "unfiltered," "infected," for examples from a recent class. Once they have a list of its qualities as an imagined object, they are ready to begin translating those qualities into metaphoric and imagistic con-

ceptualizations of the aesthetic qualities of a hypothetical production of the play or story. The experience of defining a work's qualities is a generative step toward the overall experience of conceptualizing and eventually staging and producing a theatrical production.

An experience is more than a series of undefinable qualities that coalesce into a random set of happenings, however. Qualities are the stuff of embodied interactions—or situations—between organisms and their world. Dewey writes, "The selective determination and relation of objects in thought is controlled by reference to a situation . . . so that failure to acknowledge the situation leaves, in the end, the logical force of objects and their relations inexplicable."[10] Without context or completeness in the conscious mind, the qualities of experience remain lost pieces of a grouping of mixed-up puzzles. An experience, in its wholeness, must contain objects, their qualities, and their contextual reference within a situation. In the production module example described previously, students not only make themselves and each other reflectively aware of the play or story's embodied qualities but then refer them to a central image: "The play is botched surgery," for an example of a metaphor that recent students articulated. The students situate the qualities of the object (the play or story) into a unifying image that can lead them through the analysis of the situation (the play, its qualities, and its unifying image or metaphor) and into developing habitual perspectives through which they continue the learning experience.

Habit is inextricable from an understanding of human experience. Habits are the predetermined conditions, lenses, and biases that every individual brings to the qualities and situations that make up their experience. Habits, based on amalgamations of prior experiences, guide how we engage with qualities and, therefore, how we come to view certain situations. Taking a step further, our predecessors' habits in the structuring and sequencing of certain experiences similarly shape how we engage with the qualities of our experiences. Dewey gives this history its precedence: "We live from birth to death in a world of persons and things which in large measure is what it is because of what has been done and transmitted from previous human activities. When this fact is ignored, experience is treated as if it were something which goes on exclusively inside an individual's body and mind."[11] As students move into this next stage of the production experience, they bring with them their and their peers' articulations of the qualities of the play, a situated conceptualization of those qualities in the form of image or metaphor, as well as their past experiences, what they have seen done before them, the course or module's structure, and the constant guide of their teacher(s). I find Dewey's concept of habit a useful way of thinking about what I

am working with each student to develop: a lens to look through and the tailor-made conditions within which they create. The imagistic and metaphorical thinking, I find and believe, is deeply embodied because much of the language students use to describe the play or story's "body" is often rooted in bodily experience.[12]

Depending on our habits and the habits of those who came before, whether we accept the embodied histories of others' past experience, our responses to quality and situation may be synthesizing and lead to further growth, or they may lead us to dead ends, uncertainty, and confusion. It is this hope for the "consummation" rather than the simple "cessation"[13] of experience that leads Dewey to an "aesthetic experiencing" that I think is most central to our goal in the theatre-training ecosystem. Dewey's image of the "flowing river" of experience is precisely how I envision the production module described above: a cyclical experience that scaffolds conceptualization (describing a play or story's physical qualities and situating them into a central image or embodied metaphor), rehearsal, the development of habits (the lenses and conditions of creative activity), and performance, then repeating back through quality, situation, analysis, and the reevaluation of habit.

In *Art as Experience*, Dewey most clearly articulates what it means to *have* an experience and the intensity of the depth at which its constituent parts must be integrated. As I move on to the ecosystem metaphor for culture, artmaking, teaching, and learning, Dewey's articulation of experience clarifies how harmonious the dynamic system of human experience can and should be. After giving a number of examples of experience that are profound enough to make us say, "That *was* an experience," Dewey writes, "In such experiences, every successive part flows freely, without seam and without unfilled blanks, into what ensues. At the same time there is not sacrifice of the self-identity of the parts. A river, as distinct from a pond, flows. But its flow gives a definiteness and interest to its successive portions greater than exist in the homogenous portions of a pond. In an experience, flow is from something to something. As one part leads into another and as one part carries on what went before, each gains distinctness in itself. The enduring whole is diversified by successive phases that are emphases of its varied colors."[14] The phases, or constituent qualities and the situations they make up, emphasize certain colors of an experience that make it special, worthwhile, educative, and further growth-inducing.

Constructing a cultural-cognitive ecosystem designed to foster experience that flows requires considering not how we can transmit information across a barrier of experience to inexperience; rather, it has to do with the attempt to couple, integrate, coordinate, emerge, and encourage

the self-organization and maintenance of ideas, knowledge, information, relationships, and experimentation all at the same time. So long as all this activity leads to structures that generate more growth and possibility, then the ecosystem thrives.

In order to conduct an analysis of to what extent the system is growing and diversifying, we have to be able to determine some unitary boundaries. The boundaries of what constitutes the unit of analysis for the cognitive ecology of a theatre-training setting, however, are incredibly variable because they contain elements as disparate as the tangible and internal (individuals; classes and groups; tools and props; theatre and performance spaces; callboards and email communications; and the curriculum and course syllabi, for example) to the ephemeral and external (culture and themes; politics and social movements; arts funding; and the local, national, and global theatre industries). Analyzing these composite, interlocking units can help us to better know how an experience works and how we might adjust its qualities and situations to better iron out its seams. In the following section, I develop a deeper understanding of how ours and our students' embodied cognition might influence the kinds of experiences we endeavor to create inside our ecosystems of learning.

Experience as Distributed Cognition

Distributed cognition asserts that human cognition does not have a center, that cognition is in a constant dialogic relationship with the body and the environments in which it is learning. Dewey himself suggested a similar thought over one hundred years ago: "Thinking, or knowledge-getting, . . . involves the explorations by which relevant data are procured and the physical analyses by which they are refined and made precise. . . . Hands and feet, apparatus and appliances of all kinds are as much a part of it as changes in the brain."[15] This way of looking at human thought is central to forming a philosophy of experience in educational and training settings. Hutchins writes, "Unlike extended mind, distributed cognition does not assume a center for any cognitive system. Nor does it grant a priori importance to the boundaries of skin or skull."[16] In terms of experience, Dewey holds that it does not occur in a vacuum: "There are sources outside an individual which give rise to experience. It is constantly fed from these springs."[17] These outside springs that feed individual learning experiences in ecosystems of training range widely in architectonic form: spaces (environments), technologies, social and institutional webs or hierarchies, projects and assignments, feedback, notes, grades, roles in a production, students, staff, faculty, administrators, policies, individual relationships, communications systems, curricula, and any other dynamic

and mutable elements or systems contained within the ecology of the department, program, or organization.

When recognized as distributed processes, all these elements of an ecosystem of learning can help determine the centers and boundaries of the cognition distributed across and among all the individuals within the system. When recognized as self-contained elements of individuated cognition each with their own center and boundaries, on the other hand, the ecosystem can narrow or even shut down cognition, much in the same way that disconnected experiences, though perhaps enjoyable or interesting in isolation, can lead to the "centrifugal habits," to which Dewey refers as "miseducative." Hutchins clarifies: "Distributed cognition is not a kind of cognition; it is a perspective on all of cognition. Distributed cognition begins with the assumption that all instances of cognition *can be seen* as emerging from distributed processes. For any process there is always a way to see it as distributed. . . . Thus, to take the distributed perspective is . . . to choose a way of looking at the world, one that selects scales of investigation such that wholes are seen as emergent from interactions among their parts."[18]

We can select a certain scale within the ecosystem to investigate—a workshop in an acting class, for example—and determine its boundaries of analysis: the workshop leader's goals, the number of participants, and the studio's spatial makeup. Within that particular scale, however, as Hutchins notes, "the boundary of the cognitive unit of analysis may shift dynamically during the course of activity."[19] For example, questions, personal and group discoveries, breakthroughs, and confusions all tend to emerge from acting workshops and would therefore become new elements that expand the breadth and depth of the distributed process's unit of analysis. In practice, the scale under investigation can be predetermined by the instructor as a unit of activity to analyze either in solitary reflection (e.g., simply taking notes on how a certain activity went) or as a group oral processing session. When taking the distributed perspective, however, the instructor's predetermination of the boundaries of that scale must be open to expansion or contraction depending on what happens during the course of the activity. By understanding the students' cognition as distributed, the instructor is accepting the inherent uniqueness of every group of students in each particular moment and cannot simply teach the same way every meeting, term after term.

The phenomenological mutability of a training experience like an acting workshop is so dynamic that I make no claim of an ability to empirically support whether it has been an educative or miseducative experience, but I think we can perhaps begin by determining the *initial* boundaries and centers of a distributed process and then analyze what emerges from that process and make the necessary adjustments. When taking the dis-

tributed perspective, the various weights placed upon the different cognitive processes that emerge from within the scale under investigation are paramount; therefore, the use of this perspective must eventually culminate in looking at the wholes to which Hutchins alludes. This means that every structured activity in the classroom or studio must be understood as unique and distinct from, though not unaffected by, past groups of students. Opting to take the distributed perspective in the classroom means that the instructor is constantly watching for what emerges from the interactions between the students and their environment, then making adjustments to the environment based on those observations all with the goal of growing—if we accept Dewey's requirement—the experience. Teaching from the distributed perspective, the instructor is constantly adjusting and placing more or less weight on certain elements: constraining or expanding the physical space, giving more or less voice to certain individuals or groups, creating space for reflection or processing, and even being willing to somewhat or radically alter the activity's initial goals. An ecology of experience will not only commit to taking the distributed perspective in the studio or classroom, but also in other formal and informal settings in the institution. This commitment comes with great responsibility.

Shaun Gallagher argues that if we think of the mind as operating "in dialectical, transformative relations with the environment,"[20] then our access to cognitive processes has a broader reach that extends to the institution as a whole. "We create these institutions via our own (shared) mental processes, or we inherit them as products constituted in mental processes already accomplished by others. We then engage with these institutions—and in doing so, participate with others—to do further cognitive work. These socially established institutions sometimes constitute, sometimes facilitate, and sometimes impede, but in each case enable and shape our cognitive interactions with other people."[21]

It is this inheritance of the products of others' previously accomplished mental processes that I think concerns us most as the designers, administrators of, and teachers within the mental institutions Gallagher describes. If we take the distributed perspective on our own and our students' cognition, then we must be intentionally aware of and take direct responsibility for the materials—social and emotional as well as tangible—with which our students mentally mingle. Gallagher continues, noting that "tools, technologies and institutions often shape our cognitive processes, make our brains work in certain ways, and may even elicit plastic changes in neuronal structure."[22] Seen in this way, both the tangible and intangible institutions we explicitly design and often implicitly emit have very direct and tangible effects on our students' brains and bodies. Gallagher concludes, "We should take a closer and critical look at

how social and cultural practices either productively extend or, in some cases, curtail mental processes. . . . It is therefore important to ask what such mechanisms or practices or institutions do to us as agents and as subjects of cognition."[23] I contend that the social and cultural practices that we consciously and unconsciously produce and then inject into the shared mental spaces of our students have a major impact on the boundaries and centers of their experiences.

Cultural practices such as signs, symbols, rules, handbooks, policies, and all the other signposts that help make human experiences perceptible on an integrated and contextualized level are key to reducing distracting stimuli that otherwise impede learning. As Hutchins writes, "Cultural practices tend to reduce entropy (increase predictability) at all scales in a cultural cognitive ecosystem. This is important because a brain that is a prediction machine . . . will require predictable experience."[24] In order to more confidently ensure educative experiences, we need cultural structures we can all plug into and connect to our shared experiences. If we intentionally produce cultural practices and experiences that productively extend mental processes, we may be able to construct ecologies of experience that encourage unfettered distributed processes, but also reduce the unwanted static that such stimulative environments so often generate.

These ecologies ought to be based on emergent elements from embodied experiences in which we have all shared and engaged. Clark suggests, too, that we carefully distinguish between the development of our own, native distributed reasoning models like social and cultural structures, and those of outside interferences: "Action and perception . . . work together to reduce prediction error against the more slowly evolving backdrop of a culturally distributed process that spawns a succession of designer environments whose impact on the development . . . and unfolding of human thought and reason can hardly be overestimated."[25] Perhaps by intentionally defining and continuously evolving the cultural practices and structures of our institutions, we can increase the predictability of ours and our students' experiences, all the while mitigating the impact of environments whose designers intend to distract our attention, hawk their wares, or otherwise interrupt educative experience. Hopefully we can work toward generating models of experience that can be more and more thoroughly accessed via what Clark calls "embodied, problem-simplifying action."[26]

Cultural-Cognitive Ecosystems Embodied in Practice

To whatever extent we begin to understand experience as situated within cultural-cognitive ecosystems, we must recognize the body as the locus

of an individual learner's interactions within the extant mental institutions and the physical environments of the cognitive ecosystem. Hutchins points out, "As the points of contact between organism and environment come to be seen as loci of essential processes rather than as barriers and boundaries to be crossed, the role of the body in thinking comes to the fore."[27] The distributed perspective places the bodies of the teachers and learners in the ecosystem at the center of every activity, formal or informal, and therefore places a significant emphasis on praxis, the practical integration and application of theory, history, and literature. As the production module I proposed early in the paper implies, we ought to structure curricula, courses, modules, and even individual activities in ways that centrally engage the students' bodily experiences.

In a more traditional college or university structure, I envision a Theatre History course offered not in a lecture hall or classroom with rows of chairs and tables, but in an open acting studio or even on the stage of the theatre. What better way to put history into our students' bodies than to allow them the physical space to move like an English Restoration actor or commedia dell'arte performer, to bring costumes into class for them to try on, or even to spend a class staging scenes from a Noh text? To take it a step further, I envision the same course not only taught in a studio or onstage, but backward, from contemporary to origins, so as to engage the qualities of each play and its period beginning where students have *more* situational context from which to analyze and develop habitual frames of experience at the beginning of the course, rather than less. Since space availability is inevitably an issue for most theatre-training programs, I envision six-to-nine credit, block-scheduled, and team-taught courses held in the theatre or studios where performance and literature or theory are integrated, applied, and embodied.

Working from the distributed perspective and influenced by Dewey's quality-to-situation/analysis-to-habit cycle of experience, the cultural-cognitive ecosystem for which I advocate is always evolving, much like ourselves (our bodies and minds) and the natural and technological worlds in which we live. It is difficult to envision a traditional institution with its accrediting bodies and curriculum and assessment enforcement committees being able to keep up with the ever-evolving nature of any true ecosystem. However, the process of theatrical production is an almost perfect example of how we can and do come together to consciously form a cultural-cognitive ecosystem that coordinates experience piece-by-piece in a seamless flow of parts. As Evelyn Tribble argues, "Studying culturally complex cognitive ecologies allows insight into the strategies used to structure and coordinate novel forms of skilled group action engaged in 'meshed' thinking."[28] Our productions are an amalgamation

of cognitive processes and experiences folding into one another in such a way that the group begins to think, perform, and learn as a whole. As we design new and make changes to existing theatre-training settings in various institutions, I suggest that we look back to Dewey for initial inspiration, and forward to distributed modes of cognition and to cognitive ecologies to give us insights into what might work best for us and our students.

Notes

1. John Dewey, *Experience and Education* (New York: Touchstone, 1997), 89–91.

2. Ibid., 28.

3. Andy Clark and David J. Chalmers, "The Extended Mind," *Analysis* 58 (1998): 10–23. In this seminal paper, Clark and Chalmers argue that external objects can play an important role in an individual's cognition. For example, a notebook plays as much a part in an individual's thought as their brain because it houses knowledge and information they can access and engage with cognitively.

4. Edwin Hutchins, "Cognitive Ecology," *Topics in Cognitive Science* 2, no. 4 (2010): 705–15.

5. John Sutton and Evelyn Tribble, "Cognitive Ecology as a Framework for Shakespearean Studies," *Shakespeare Studies* (2011): 94.

6. Edwin Hutchins, "The Cultural Ecosystem of Human Cognition," *Philosophical Psychology* 27, no. 1 (2014): 45.

7. Dewey, *Experience and Education*, 25–26.

8. John Dewey, *Experience and Nature* (London: George Allen and Unwin: 1929), 86.

9. Dewey, *Experience and Nature*, 86.

10. John Dewey, *John Dewey: The Later Works 1925–1953, Vol. 5*, ed. Jo Ann Boydston (Carbondale: Southern Illinois University Press, 1984), 246.

11. Dewey, *Experience and Education*, 39.

12. For an excellent and detailed book about the embodied nature of metaphors, see George Lakoff and Mark Johnson, *Metaphors We Live By* (Chicago: University of Chicago Press, 2003 [1980]).

13. John Dewey, *Art as Experience* (New York: Perigee, 1980), 35.

14. Dewey, *Art as Experience*, 36.

15. John Dewey, *The Middle Works of John Dewey: 1899–1924, Vol. 10*, ed. Jo Ann Boydston (Carbondale: Southern Illinois University Press, 1980), 328.

16. Hutchins, "The Cultural Ecosystem of Human Cognition," 37.

17. Dewey, *Experience and Education*, 39.

18. Hutchins, "The Cultural Ecosystem of Human Cognition," 36, original emphasis.

19. Ibid., 36.

20. Shaun Gallagher, "The Socially Extended Mind," *Cognitive Systems Research* 25–26 (2013): 7.

21. Ibid., 7.

22. Ibid., 7.

23. Ibid., 11.

24. Hutchins, "The Cultural Ecosystem of Human Cognition," 38.

25. Andy Clark, "Whatever Next? Predictive Brains, Situated Agents, and the Future of Cognitive Science," *Behavioral and Brain Sciences* 36 (2013): 195.

26. Clark, "Whatever Next?," 243.

27. Edwin Hutchins, "Cognitive Ecology," *Topics in Cognitive Science* 2 (2010): 710.

28. Evelyn B. Tribble, "Distributed Cognition, Mindful Bodies and the Arts of Acting," in *Theatre, Performance and Cognition: Languages, Bodies and Ecologies*, ed. Rhonda Blair and Amy Cook (New York: Bloomsbury, 2016), 140.

Embodying the Ever-Present Past

The Integration of Tuskegee High School

Tessa W. Carr

> There are always important public events that could be dramatized, but . . . we have to care to make it important using documentary. The hyper-theatricalization of contemporary culture can itself lead toward a valoriza-tion and desire for "facts," for the materiality of events, for a brute display of evidence as a reaction against the fear of total fiction when all else fails. When historical archives are doubted (e.g., the Holocaust deniers), there is not much to do besides point to the bodies of evidence and demand they not be discounted.
> —Janelle Reinelt, *Dramaturgy of the Real*

I N DOCUMENTARY THEATRE the bodies of evidence are config-ured from speech, skin, paper, celluloid strands, digital pixels, sound bites, breath, and whatever other means necessary to tell the story. This paper explores the tensive and productive relationships between the mul-tiple configurations of bodies involved in creating the original work *The Integration of Tuskegee High School: Lee v. Macon County Board of Edu-cation*. Built from oral history narratives, archival research, and auto-biographical texts, *The Integration of Tuskegee High School: Lee v. Macon County Board of Education* was produced in 2016 with students at Au-burn University in Auburn, Alabama. The play was performed for over 2,000 people in three venues in Alabama, with fourteen performances at the university. There were fifteen talkbacks and numerous community outreach events, as well as a special performance in which nearly all in-terviewees and their families were brought together to hear their stories in dialogue for the first time ever. The online video of the performance has been viewed over 1,000 times.[1]

The performance event radiated outward and allowed for a critical meeting place where audience members could share similar stories of their experiences of living through desegregation. This meeting place creates what Kathleen Gallagher has named "a physical and discursive

space in which difference can live, empathy can be generated, and a realization that we are better off together than apart can be reified by sitting and listening together."[2] The creation of this critical meeting place in performance highlighted the embodied witnessing taking place, not only for the audience members, but also for the student actors involved in the project and changed their understanding of the educational institutions in the state of Alabama and their individual roles in this complicated history. I am not arguing that the social wounds of the Jim Crow era were healed through performance; rather that the gaps, the losses, and the resounding silence of fifty years were revealed and perhaps mitigated somewhat.

Contextualizing the production with a brief historical overview, I delve into the ethical questions and dilemmas faced when adapting oral history narratives of living subjects for performance. Examining how the ethical guidelines of performance ethnography and oral history performance led to the creation of a polyphonic and open text, I then move to how the performance event created a space for co-witnessing and public dialogue about events that had previously remained silenced. The staged embodiment of these stories and the subsequent conversations functioned as a partially redressive event for a community trauma that was still incredibly fresh for the majority of the people who shared their oral histories of living through desegregation.

Historical Context

Tuskegee, Alabama, is a legendary place in the history of civil rights in the United States. Through the well-organized and courageous work of the Tuskegee Civic Association throughout the 1950s and 1960s, cases for voting rights and the redistricting of a gerrymandered Tuskegee were filed and won by Attorney Fred Gray. (In interacting with community members from Tuskegee, I learned that Fred Gray is nearly always referred to as "Attorney Gray" as a mark of respect.)[3] Earlier, Gray had also served as an attorney for Dr. Martin Luther King Jr., Rosa Parks, and Claudette Colvin. In 1963, Gray filed *Lee v. Macon County Board of Education* to force Alabama's adoption of the Supreme Court ruling on desegregation established in 1954 in *Brown v. Board of Education*. *Lee v. Macon* was brought by the families of thirteen African American students who wanted the same education for their children that was offered to their white counterparts. When the federal courts refused to dismiss this direct challenge, both the white and African American communities of Tuskegee began to make plans for the coming inevitable desegregation.[4]

However, on September 2, 1963, Governor George C. Wallace ordered

state troopers to surround the school and not allow anyone—white or African American—to enter the building. Subsequently, he ordered the school closed for one week and deployed more troopers and eventually the National Guard to enforce his resistance to the federal ruling. What followed tore at the roots of a community that was working through a contentious progress on civil rights. Within a week, the National Guard would be federalized and stood down by President Kennedy and the school would reopen for the admittance of the thirteen African American students. To make a very long and fascinating story short, with the forced desegregation of Tuskegee Public High School, on September 10, 1963, thirteen African American students were admitted, and by the end of the first week every white student in the school had withdrawn. Governor Wallace's week of closure had given time and space for a private school movement to organize.[5] In Tuskegee, by February 1964, the Macon County Board of Education had closed Tuskegee Public, split the African American students into two groups, and used them to desegregate two additional county schools.[6]

Groundwork and Guides

Beginning in 2011, Dr. Mark Wilson, director of the Caroline Marshall Draughon Center for the Arts and Humanities at Auburn University, and students from his community and civic engagement class partnered with the Tuskegee History Center to identify people who had lived through the desegregation and who might be interested in participating in a fiftieth anniversary event. The interviews that resulted, along with ones previously recorded by Dr. Robin Sabino, added local, orally transmitted knowledge of events related to desegregation. The students would ultimately organize and host a symposium at the history center to honor the fiftieth anniversary of the desegregation of the school and the interviewees. The project successfully culminated in a symposium covered by C-SPAN and still available for review online.[7] The community partnerships, not only with the history center but also with the interviewees, would continue to play an integral role in the life of the dramatic work.

In the spring of 2014, I met Dr. Wilson and learned about the tremendous project that he and his students had completed. He asked me if I would be willing to look at the interview transcripts and see if "there might be a story there" that could be dramatized. When Dr. Wilson turned the nearly forty hours of transcripts and audio and video recordings over to me, I found that they included accounts from twelve white former students, seven African American former students, an African American woman who was the daughter of one of the teachers at the

all-black elementary school, a white woman, now in her nineties, who was the parent of two children who attended Tuskegee Public schools, and a white woman whose mother had been a teacher at Tuskegee Public High School.

As I began reading and filtering the stories of individuals from another time, space, and experience than my own, I was acutely aware of my own complicated history as a white female academic of Southern heritage now teaching at a PWI (predominantly white institution). I knew that I would have to seek guidance from the interviewees at each step in the process to avoid (as much as is possible) grafting my own preconceived ideas and incomplete knowledge of desegregation upon the production. I was also asking for their trust. These participants had offered their accounts within the specific context of having the recordings housed in an archive. Now, I was asking to take that story and reconfigure it into a performance, thus taking their stories to a new level of public embodiment. As Della Pollock has eloquently written, oral history is already a fundamentally embodied act of attenuated telling and listening between the interviewer and interviewee. The performance of oral history narrative not only calls forth the initial embodied transmission of the knowledge, but also "translates subjectively remembered events into embodied memory acts, moving memory into re-membering. That passage not only risks but endows the emerging history/narratives with change."[8] Reassuring the participants that my primary aim was to honor their telling of the history, I secured permission from the interviewees to include pieces of their narratives in a performance script. I assured each participant that they would have final say over whether or not their comments were included. I did not promise that they could edit but rather that once they saw the proposed final script they could decline inclusion if they so wished.

I conceptualized the work as a complex collage of a moment in time, and coded[9] the interviews for themes and perspectives that would create what Dwight Conquergood named a dialogic performance text: "This performative stance struggles to bring together different voices, world views, value systems, and beliefs so that they can have a conversation with one another. The aim of dialogical performance is to bring self and other together so they can question, debate, and challenge one another."[10] With their origins in dialogue, oral history texts offer rich source material that is already a negotiation of meaning between two participants. By scripting the discrete interviews into a larger public dialogue that could speak to multiple and often competing interpretations of "what happened," the script might, as Pollock writes, challenge "the textual drive toward narrative resolution and the conventional authority

of more objective or objectifying modes of knowledge and representation with the power of open telling."[11]

Embodied performance would highlight the differences in experiences and understandings. For instance, just when the audience might think that a definitive point of view on a particular event had been established, a different character would speak just as definitively from his or her perspective and contradict the implied authority from the previous account. Portrayed with sincerity and conviction, the accounts would stand as simultaneously true and questionable alongside each other. The actors portraying both the white and African American students from the era would bring into a performative public dialogue youthful perspectives that had not been part of the official record of events.

Community Trauma

As I continued coding the interviews for thematic content, I watched and listened closely for physical implications of intense emotion or affect. I was transfixed by the passion within the narratives, evidenced by changes in breath, physical movements that revealed a closing off of the body or a leaning in toward the interviewer, and the times when participants would circle back to pieces of the story that they felt had not been sufficiently explained. It quickly became evident that for many of the interviewees this was a witnessing to a traumatic event. Accounts of traumatic events may contain gaps, silences, instances of aporia (an irresolvable internal contradiction), expressions of cognitive dissonance, and a continual leaving or avoidance of the site of trauma.[12] One interviewee emphatically named the scene of the troopers surrounding the school "dramatic and traumatic,"[13] her voice shaking with outrage; another interviewee paused for a long moment before stating with a solemn and slightly quavering voice, "That day is implanted in my mind for my whole life—I can't escape it."[14] Throughout the interviews, when the day of desegregation arrived in the telling, voices changed, pauses became more noticeable (sometimes shorter as speech sped along and sometimes lengthier). Listening closely for changes in breath and vocal intensity, I felt my own breath slow down and my focus sharpen as I was emotionally moved by the deep sadness and regret I heard.

The traumatic nature of that week in Macon County was further revealed as interviewees spoke of a feeling of the inability to tell the whole story, that there was not a right or complete way to tell it, through deep rationalizations over why making a choice that benefited your family was more important than one that focused on the health of the community,

and the vigor with which the sometimes sad, ambivalent, and anger-filled partial stories emerged from participants. From the interviews, a community fracture emerged that could not physically be put back together, but within the rift was intense curiosity to hear what the other side had to say so many years later. There was a need to circle back to the site of the event and piece together a story. By highlighting the very different understandings of what had occurred and the complexity of feelings that circulated, the production could acknowledge each side's interpretation and potentially open a space for listening to whatever collective knowledge emerged.

Bodies in Dialogue

The vividness of the memories, the pain of the telling evidenced in the voices and bodies of the tellers, alerted me to the fact that I had to move with extreme care in constructing the script and its embodied performance. Feelings of fear, humility, and excitement washed through me during the initial drafting process, and I felt the weight of the responsibility within my physical body to "say it right, say it correct," as Father Schmidt exhorts in *The Laramie Project*.[15]

Throughout the stories, the differences between the African American and white experiences were obvious and revealed through breath and voice in the interviews. The African American students felt they were participating in something momentous, important, and frightening. The white students tended to think of it as more of a nuisance or curiosity. One white interviewee stated with a laugh that he was "youthfully naive" in his belief that desegregation would not be a disruption.[16] Another white interviewee laughed and shifted: "We were worried about playing ball" (in reference to football and how it might be disrupted with desegregation).[17] This laughter and nervous movement did not read as flippant, but rather as discomfort and chagrin. The voices of the African American interviewees were more often solemn and filled with pride and energy from the awareness that their actions would be part of a larger movement. What also became evident were the differences in understandings of how the events transpired, what the events meant, how the "other side" interpreted what had happened, and how these events from the past continue to haunt lives and societal structures today.

The major thematic content that emerged included the recollection on both sides of an idyllic impression of the town of Tuskegee; the African American students recalled excellent schooling they received through the Chambliss Children's House school on the campus of Tuskegee Univer-

sity (an HBCU—historically black college or university) before deseg-
regation; there was preparation on both sides for the desegregation—
including the rigorous academic and psychological testing that the
African American students underwent; a feeling from the white stu-
dents that desegregation would be only minimally disruptive and that
their high school world could be managed if they only made plans; the
shock of the governor's intervention; the upheaval caused by the white
parental response; the fear and stoicism of the African American stu-
dents as they were ferried on a bus with federal marshal escorts; and fi-
nally the disintegration of the school due to white flight. With each major
theme, I grouped conflicting and concurring understandings and created
dialogues between characters. However, as Ellen Wimbish, one of the
youngest African American students, stated about the similar summer ac-
tivities enjoyed by students of both races, "You go to summer school in
the morning, you go home, kind of rest, get up, and then you either go
swim or the boys played baseball. Yeah, we didn't sit around too much—
but the relationship between blacks and whites was separate."[18] In per-
formance, each group of students would speak of their lives and prepa-
rations for the coming desegregation, but they would only speak with
students of their race.

Using Robert Norrell's extensively researched text, *Reaping the Whirl-
wind: The Civil Rights Movement in Tuskegee*, as a guide for piecing to-
gether the historical timeline, I brought in a group of student drama-
turgs from Auburn's Mosaic Theatre Company[19] to participate in the
final construction of the initial text. Working with the students deep-
ened my awareness of the ethical challenges we faced. As we sat around
a conference table, reading sections aloud for pacing and flow, on several
occasions I had to stop a student from cutting lines when ideas were re-
peated by several speakers, or when it would be expedient to shorten a
line to the "powerful" parts but would result in a loss of deeper context.
I reminded the students of Pollock's admonition that "insofar as oral his-
tory is a process of *making history in dialogue*, it is performative. It is
co-creative, co-embodied, specially framed, contextually and intersub-
jectively contingent, sensuous, vital, artful in its achievement of narra-
tive form, meaning, and ethics, and insistent on *doing through saying*, on
investigating the present and future with the past, re-marking history
with previously excluded subjectivities, and challenging the conventional
frameworks of historical knowledge with other ways of knowing."[20] In
performance, the sections with repetition became fast-paced collages,
with the voices bouncing back and forth between the white and African
American communities, the characters in each segregated community

hearing only their peers' responses. The repetition of similar experiences from people living in adjacent worlds with vastly different access to educational resources reinforced the shared aspirations of these young voices and immediately highlighted the inequity of opportunity faced by the African American students. The actors, both African American and white, stood meticulously groomed in dresses and slacks and button-down shirts juxtaposed in front of photographs of the interiors of schools from the era. The disparity between the "separate but equal" educational settings was obvious, as was the desire of the African American students to be afforded an equal education.

The initial script we created included the voices of six white students, one white parent, and seven African American students. While this breakdown privileged numerical equality of bodies on stage, there was more focus in the text upon the African American student perspective. This choice was supported by the idea that those were the student bodies that had actually experienced the desegregation, as the white students had ultimately departed Tuskegee Public and could only speak to the initial closing of the school. No words were changed or added to what had been said by interviewees.

The first version of the script was performed at Tuskegee United Methodist Church in November 2014 for an audience of over 150 people, both African American and white, ranging in age from middle school students to senior citizens. This performance was a simple staged reading reliant primarily upon the actor's voices, and was initially planned as the culmination of the work to honor the interviewees. The embodied performance was also an essential piece of pedagogy. The student performers and I had to hold ourselves publicly accountable to the community that we were portraying. As I began to run the simple slides that named each speaker, I felt the most intense anxiety I have ever experienced as a director. The response was overwhelmingly positive and a talkback planned for twenty minutes ran to nearly forty-five, with many varied and emotional responses shared. Before the performance even began there were several people openly crying in the church. Just the sharing of space evoked tremendous embodied reactions around this still-charged topic. One of the most powerful responses was from a woman (later identified as an attorney colleague of Attorney Gray) who stated that Gray's voice was missing from the work and should be included.

It became clear to me that if the work was to continue, then the next step was to broaden the dialogue by incorporating the official printed archive—monographs, newspapers, government documents, etc.—alongside the knowledge that had been shared through orality. With

the support of the Auburn University Department of Theatre, I began work on the script that would become the mainstage production in the spring of 2016.

Embodying the Archive

The mainstage script would never have been completed without the vigorous and committed help of my assistant director and dramaturg, Richard Trammell. As we sifted through so much material, Richard and I created a visual and embodied system to make sense of the work. We read pieces aloud to each other; we played music from the era that we hoped would reinforce the pace that we wanted for a section; we printed everything, cut it into pieces, and physically reassembled it on giant post-it notes. We did this until we had chunks that we felt held to our guiding principles. I then took over the final sequencing, transitions, the selection of a few pieces of music to be included, and the creation of projection slides that would help to guide the audience.

Researching through multiple news accounts, we were acutely aware of Janelle Reinelt's admonition that the creative treatment of archival documents in service of storytelling is a slippery slope. The documents represent an "acknowledged reality" that is always referenced but never present in documentary. Documents cannot speak for themselves and are therefore always already constructed into coherence by the artist and brought to life through performance embodiment.[21] In keeping with the goal of creating a dialogic performance that could invite interrogation, I included multiple news accounts from local, state, and federal newspapers. In performance, these accounts would be embodied by actors playing reporters. The reporters would be onstage nearly the entire play. They would circulate and take notes, listen and observe, witness and report what was happening—utilizing only the words from the archival story as their dialogue. They spoke in direct address to the audience. As they spoke, the headline and photographs from the archived paper would be projected. A key alternative voice was the *Birmingham World*, an African American newspaper that was an important and rare non-mainstream source of information from the era.

A new narrator guide was created from the autobiography of Attorney Gray. With the cooperation of Gray and New South Press, we incorporated excerpts from his autobiography, *Bus Ride to Justice*, to offer insight into the legal path the case took through the courts and the ramifications of Wallace's actions on the case. The embodied portrayal of Gray differed from the other named characters (interviewees). Gray could move throughout the worlds of both black and white characters. Even though

Figure 7.1. (*Left to right*) Attorney Fred Gray and actor London Carlisle after a performance of *The Integration of Tuskegee High School.* Courtesy of the College of Liberal Arts, Auburn University.

he was often explaining a complex legal aspect to the audience, if there were other characters onstage, then they too could hear him and acknowledge what he was saying. As in life, in the play he was the only character who could move between the segregated worlds (figure 7.1).

Alabama state documents provided the dialogue for Governor George Wallace, including his infamous "Segregation Today, Segregation Tomorrow, Segregation Forever" speech.[22] Wallace's character was physically separated and spoke from an upper balcony above the town square space where the other characters interacted. The physical separation would clarify the power dynamics between the citizens of Tuskegee and Wallace. Throughout rehearsals for the production, the actor portraying Wallace was above the rest of the cast each night. When he came down for notes at the end of the night, the cast had him run through a line of high fives as a welcoming ritual, creating an embodied reconciliation and return to the company each night. Finally, the 1968 dissertation by E. W. Wadsworth, the principal of Tuskegee Public at the time of desegregation, provided insights through interviews and documents that would have otherwise been lost.[23] This included a key account of an all-white community meeting on the eve of the school closing. This account illuminated the animosity and fear that was circulating in the town and that

Figure 7.2. A scene from *The Integration of Tuskegee High School* in which Daphney Portis as Wilma Jones Scott rips up a gubernatorial directive. Courtesy of the College of Liberal Arts, Auburn University.

in performance was embodied as a near shouting match with the audience members cast as the attendees being addressed by the actors (figure 7.2).

While the oral history interview script remained the heart of the script, the archival "truth" pieces added corroborating information. Sequencing these pieces as keepers of the chronology of events, I continued the work of juxtaposing differing accounts, but now that focus moved to highlighting the differences in tone and voice between the news accounts—particularly the local, regional, and national differences. The oral history narratives spoke back to the news accounts, while Gray guided the audience through the intricacies of the legal case as he countered each of Wallace's moves. The goal was to performatively capture the dynamic multi-voiced and action-filled events of the week.

Bodies in Performance

On April 16, 2016, we brought together all the participants and their families for a special performance. Open only to those involved in the project and their guests, the theatre was packed to overflowing with invited friends and family. Attorney Gray and all the living interviewees who were able to come were in attendance. Two of the participants were

Figure 7.3. *The Integration of Tuskegee High School* cast and interviewees, Auburn University, 2016. Courtesy of the College of Liberal Arts, Auburn University.

Anthony T. Lee and Willie Wyatt Jr.—African American students who had not only been part of *Lee v. Macon*, but who had come to Auburn in 1964 as the first undergraduate students of color to continue the legacy of desegregation. They had not returned to Auburn until their contributions toward desegregation were formally acknowledged by the university in 2013. The energy in the theatre that day was palpable, a mixture of anticipation, nostalgia, anxiety, and uncertain expectations (figure 7.3).

The performance was set in the black box theatre in three-quarter thrust formation with 125 seats. A minimal set that represented the town square of Tuskegee with some abstract museum-like light panels created an open playing space. The only additional staging was created through the use of six simple acting blocks that could be moved and reconfigured. Time and location were realized through projections, a capella singing of period songs, and historically specific costumes and wigs on the student performers. In the words of performance scholar Carol Martin, it was hoped this would position "the frame of the stage not as a separation, but as a communion of the real and simulated; not as a distancing of fiction from nonfiction, but as a melding of the two."[24] The juxtaposition of the simple nonrealistic setting with the period-specific details created a world that was neither of this moment nor attempting to be a realistic

recreation of the play's time period, thus embodying the interplay between remembered accounts and archival pieces from the era.

The production opened with the embodied establishment of segregation, as cast members entered in pairs and small groups singing "I'm Going to Sit at the Welcome Table" a capella. As both African American and white cast members crossed the town square setting, they enacted carefully choreographed greetings. White and African American cast members enthusiastically greeted those of their own race with handshakes or hugs, and either blatantly avoided or offered a cordial nod to those not of their race. Only the white sheriff's son, who later revealed in his dialogue the close relationships he held with African American townspeople, crossed the color line for greetings. By the second verse of the song, the cast was divided on the stage between African American and white, and the African American cast members hopefully sang, "I'm going to be a registered voter," as the white cast members uncomfortably left the stage.

The cast of characters included the fourteen interviewees plus reporter-narrators, Governor George Wallace, former Assistant US Attorney General John Doar, and Attorney Fred Gray. Upon their first individual entrance, the names, ages, and places of birth of each character were projected. Several student actors performed multiple roles, identified through simple costume signifiers. The incorporation of period costumes onto actor bodies that were approximately the same age of the historical subjects at the time of the events—juxtaposed with the fact that the text these actors were speaking was obviously from a long-ago memory— foregrounded the literal and figurative reconstruction of the memory from a specific body. This further opened the questioning possibilities of the accuracy and "truth" of the telling.

On this night, a student actor could see the original teller of the story whose words they were speaking. In rehearsal and post-show talks, student actors spoke of the "the weight" of the story that they had to tell and the responsibility that they carried in the telling. Their embodiment of these memories functioned as a form of bearing witness. According to Rivka Syd Eisner, "Bearing witness, however, does not just entail carrying memory. Bearing the past is to allow it entry into bodily consciousness and continuing social experience, so that living with memory means giving residence to pieces of the past that in turn, even in their painfulness, sustain and charge one's own being. Witnessing is a necessarily unfinished and incomplete process of sensing and knowing, of reaching out with respect toward another's life."[25]

The efficacy of the witnessing was not limited only to honoring, acknowledging, and speaking stories and perspectives never before made public into the "town square" of the theatre, but this embodied act furthered the understanding of the student actors. More than half the cast

came from private Alabama schools. Very few of the students had any idea as to the reason their schools were founded, but the vast majority discovered that desegregation was the foundational impetus. This was doubly difficult for African American students in the production who came from private academies founded for exclusion. Sophomore Jordan Kelley gave the following emotional testimony about her experience playing one of the lead African American student roles: "Being in this production and being able to hear everybody's story has blessed me with the confidence to embrace all the struggle that my people have gone through. And where it has brought me right now and probably where it is going to take me. . . . It's a lot to talk about: 'Oh I'm black and my history is rich and all this good stuff.' But when you gain the wisdom, when you gain the actual knowledge of what has happened, then that's what sets you free. And I've been set free in the sense that I am so much more confident in what I can do because of you all."[26] Jordan's was not the only account that voiced newfound awareness and knowledge. By their own words, the student performers found new relevance in the history of other bodies, and a new sense of place and power in their own.

As the audience sat close together in the light spilling from the playing space, a participant interviewee could potentially look across the square of Tuskegee, keeping in her eye-line the actor portraying her story, and see in the adjacent audience bodies of the antagonists or allies from her memories. Audience members who had lived through desegregation heard stories from such a variety of perspectives that the likelihood of an identification point was high, allowing for deeper recollection of their own memories. After each of the fourteen sold out performances, over one-third of the audience stayed for talkback, and every night we had to end the discussion after half an hour of stories, emotional pleas for understanding and unity, and accounts of guilt, shame, pride, and fear were shared. Pollock speaks to this possibility of generating new knowledge and insight through oral history performance: "At its best, it democratizes tellers and listeners by easing the monologic power of what is said into the collaborative, cogenerative, and yet potentially discordant act of saying and hearing it."[27] The possibility of reconciliation despite discord was particularly evident at the invited performance when embodied responses of emotional release and forgiveness were shared. One of the African American interviewees became overwhelmed and had to temporarily leave the theatre. While he did return, he stated in the talkback that it was as if he had returned to that moment in his life, but now he could release some of the pain and anger that he had carried. A white male interviewee who during his interview had not acknowledged the gravity of what had happened openly cried as he asked how we could move toward unity in our current divided world.

Through the careful attention to bodies—the bodies of those who lived through the event, the textual body of the stories that they offered, the construction of the body of the text and its embodied performance, the marking of the bodies of the students with symbolic costumes that both evoked the time and highlighted the gap between the telling of a fifty-year-old memory and the embodied event lived by the younger body, and the careful configuration of how the bodies in the space would interact—I believe we created for ourselves and the audience what E. Ann Kaplan and Ban Wang name as a co-witnessing position. There is the possibility that this position of responsibility "may open up a space for transformation of the viewer through empathic identification without vicarious traumatization—an identification which allows the spectators to enter into the victim's experience through a work's narration."[28] Co-witnessing is achieved by infusing the audience with a sense of responsibility while resisting narrative closure.

Reinelt reminds us that the knowledge gained from this witnessing of documentary theatre is not a static body, but one continually shedding and gaining understanding: "The reality is examined and experienced differentially; it is produced in the interactions between the document, the artist and the spectator. It is never enough. Desire outstrips what is or can be provided. The shards of the document are tattered and thin. The mediation is always suspect. And yet . . . it has its measure of efficacy; it is a way of knowing."[29] Toward the end of that powerful night of performance and talkback, Attorney Gray pointed out, "It has taken over fifty years of the fight for unity . . . for the students who were at that school to express their views. It shows that if we understand and if we communicate, we will be able to solve a lot of our problems."[30] This may be true if solving our problems includes creating those critical meeting places where, as Gallagher writes, "difference can live, empathy can be generated, and a realization that we are better off together than apart can be reified through the sitting together and listening."[31] A space can be created in which an audience becomes an endorser and creator of oppositional knowledge—endorsing oppositional narratives that might upend even the understanding of those who lived through the events.

Notes

Epigraph from Janelle Reinelt, "Towards a Poetics of Theatre and Public Events: In the Case of Stephen Lawrence," in *Get Real: Documentary Theatre Past and Present*, ed. Alison Forsyth and Chris Megson (Basingstoke, Hampshire UK: Palgrave Macmillan, 2011), 39.

1. AULiberalArts, "This Is Research: The Integration of Tuskegee High School," YouTube, 3:22, October 6, 2016, https://youtu.be/oPCXOgY2iWM.

2. Kathleen Gallagher, "Politics and Presence: A Theatre of Affective En-counters," in *In Defence of Theatre: Aesthetic Practices and Social Interventions*, ed. Kathleen Gallagher and Barry Freeman (Toronto: University of Toronto Press, 2016), 70.

3. For an in-depth analysis of these cases and the history of Tuskegee, see Robert J. Norrell, *Reaping the Whirlwind: The Civil Rights Era in Tuskegee* (Chapel Hill: University of North Carolina Press, 1998).

4. For a detailed discussion of the timeline, process, and ramifications of *Lee v. Macon County Board of Education*, see Fred Gray, *Bus Ride to Justice* (Montgomery, AL: New South Press, 2002), 208–18.

5. According to the *Encyclopedia of Alabama*: "As many as 50,000 white students left public schools for these private academies from the mid-1960s into the early 1970s while the number of private schools increased from approximately 35 to more than 130 between 1965 and 1975." Gordon Harvey, "Public Education in Alabama after Desegregation," *Encyclopedia of Alabama*, March 8, 2013, http://www.encyclopediaofalabama.org/article/h-3421.

6. E. W. Wadsworth, "A Historical Perspective of Education in Macon County, Alabama: 1836–1967" (PhD dissertation, Auburn University, 1968). Wadsworth served as the principal of Tuskegee Public High School during the desegregation. After his resignation in 1964, he returned to school at Auburn University for a doctorate in education. His dissertation includes valuable insights from his experience as principal at this critical time in Alabama history.

7. C-SPAN, "50th Anniversary of Tuskegee Public High School Integration," C-SPAN, 2:43:11, August 24, 2013, https://www.c-span.org/video/?314498-1/50th-anniversary-tuskegee-public-high-school-integration.

8. Della Pollock, "Introduction," in *Remembering: Oral History Performance*, ed. Della Pollock (Basingstoke, Hampshire UK: Palgrave Macmillan, 2005), 2.

9. All qualitative coding is to a degree project-specific. The coding that I created included marking sections of interviews for context, subjective perspectives on the relationships between the races, the understanding of the series of events and the gravity of the events, physical manifestations of emotion, and the breadth of opinions and perspectives about the town in the 1960s. The coding was not completed in one cycle, but evolved over the course of multiple cycles of reading (transcripts), viewing, and listening to the interviews.

10. Dwight Conquergood, "Performing as a Moral Act: Ethical Dimensions of the Ethnography of Performance," in *Literature in Performance* 5, no. 2:1(1985): 11.

11. Pollock, "Introduction," 4.

12. Shoshana Feldman. "Education and Crisis: or, The Vicissitudes of Teaching," in *Trauma: Explorations in Memory*, ed. Cathy Caruth (Baltimore: Johns Hopkins University Press, 1995), 13–60.

13. Chris Akin Adams, interviewed by Dr. Mark Wilson, January 23, 2013.

14. Andy Sharpe, interviewed by Dr. Mark Wilson and Andy Hornsby, April 20, 2012.

15. Moisés Kaufman and the Members of the Tectonic Theatre Project, *The Laramie Project* (New York: Vintage Books, 2001), 66.

16. Andy Sharpe, interviewed by Dr. Mark Wilson and Andy Hornsby, April 20, 2012.

17. Jimmy Wilson, interviewed by Dr. Mark Wilson and Andy Hornsby, April 6, 2012.

18. Ellen Wimbish, interviewed by Dr. Mark Wilson, July 27, 2013.

19. Mosaic Theatre Company is a year-round ensemble that creates original work focusing upon issues of diversity, inclusion, and social justice. I am the artistic director of the company. The work is co-sponsored by the Auburn University College of Liberal Arts Dean's Office and the Department of Theatre.

20. Pollock, "Introduction," 2.

21. Janelle Reinelt, "The Promise of Documentary," in *Get Real: Documentary Theatre Past and Present*, ed. Alison Forsyth and Chris Megson (Basingstoke, Hampshire UK: Palgrave Macmillan, 2011), 6–23.

22. George C. Wallace, "Inaugural Address: Governor of Alabama," January 14, 1963, https://web.utk.edu/~mfitzge1/docs/374/wallace_seg63.pdf. While Wallace delivered this speech, its composition is usually credited to Klansman (and later, fake "Native American" novelist) Asa Earl Carter.

23. E. W. Wadsworth, "A Historical Perspective."

24. Carol Martin, "Introduction," in *Dramaturgy of the Real on the World Stage*, ed. Carol Martin (Basingstoke, Hampshire UK: Palgrave Macmillan, 2010), 2.

25. Rivka Syd Eisner, "Remembering Toward Loss: Performing *and so there are pieces . . . ,*" in *Remembering: Oral History Performance*, ed. Della Pollock (Basingstoke, Hampshire UK: Palgrave Macmillan, 2005), 124.

26. AULiberalArts, "This is Research."

27. Pollock, "Introduction," 2.

28. E. Ann Kaplan and Ban Wang, "From Traumatic Paralysis to the Forcefield of Modernity," in *Trauma and Cinema: Crosscultural Explorations*, ed. E. Ann Kaplan and Ban Wang (Hong Kong: Hong Kong University Press, 2004), 10.

29. Reinelt, "The Promise of Documentary," 23.

30. AULiberalArts, "This is Research."

31. Gallagher, "Politics and Presence," 70.

From Tuxedo to Gown

Dietrich's Haunted Dressing Room(s)

Bridget Sundin

The Haunted Queer Body—An Introduction

Although many feminist film scholars have written about Marlene Dietrich's body through the lens of feminist theory, psychoanalysis, and semiotics—particularly in the 1990s[1]—there is a current gap in performance studies literature regarding ways in which Dietrich's always already femme fatale body is haunted not only by her celebrity, but by her previous roles as a stage cabaret performer, which contain explicitly queer content. My essay joins the ongoing conversation about queer embodiment by braiding together three strands of theory in regard to Marlene Dietrich's theatrical performances on screen: performance phenomenology, haunting/ghosting, and queer futurity. In order to create a fuller understanding of the potential of the queer body to resist, subvert, invent, and become, I position the dressing room as both a metaphorical and literal space of transformation.

This article focuses on Marlene Dietrich's queer female embodiment and her theatrical use of tuxedo- and gown-drag, specifically situating this theatrical site of gender transformation to be the dressing room space in Josef von Sternberg's 1930 film *Morocco*.[2] To theorize Dietrich's queer-haunted embodiment in this space, I lean on Marvin Carlson's theory of ghosts and hauntedness as a method for grounding the intertextuality of Dietrich's body as she changes from tuxedo to gown.[3] I utilize my own performative queer voice in this essay as a deliberate addition to the academic archive. Embodied experiences, particularly those of marginalized populations, have historically been omitted from the archive.[4] By discussing Dietrich's queer embodiment using my own queer embodied voice,

I join scholars who are also creating new forms of theorizing queer embodiment as well as creating new methods of queer historiography.

The Dressing Room: A Haunted (Queer) Space for a Haunted (Queer) Body

Have you been in a dressing room before? Can you remember how it looks? How it smells? Can you go a little further and feel backward[5] affectively through time to an instance when you sat at a mirror putting on stage makeup, glancing over at a bouquet of flowers an admirer sent you, and maybe—if you try hard enough—can you even read the little rectangular card that says, "Break a leg!"? As I begin the body of my essay, I hope you are with me in this dressing room where the power of potential transformation buzzes in the air. Yes, there is a particularly embodied and heightened energy that takes place in a dressing room prior to a performance that involves a performer managing material objects and harnessing an array of converging internal conditions before taking the stage. The dressing room is a space unlike other theatrical spaces, in which bodies can transform into beings that have only existed in the imagination. It is here that audiences and performers alike expect the actor's embodiment to shift from ordinary to extraordinary through the use of costuming and makeup.

Depending on the theatre's architecture and/or the context of a performance itself, a dressing room experience can run a wide range. A performer may encounter everything from a no-frills makeshift curtain hung from PVC pipe in an offstage corner next to the prop table to a luxurious private dressing room complete with upscale furniture and warm, cozy lighting. As a performer moves incrementally toward the heart of a performance—from the street outside, through the stage door, into the dressing room, then off to the wings, and finally onto the stage itself— an actor uses these spatial markers to transition from their personal identity into the identity taken on in the performance onstage. The average person does not often (or ever) see this journey toward the stage. However, Marlene Dietrich starred in many films that grant us access to this journey. In these films, audiences are allowed a glimpse at such a theatrical transformation as layers are peeled back from both the on- and offstage embodiment of a cabaret performer.

It seems only fitting at this time to invite the ghost of Marlene Dietrich, dressed as Amy Jolly in the film *Morocco*, to join our dressing room talk. Ah, there she is. A vision. Black tuxedo pants, a white tuxedo shirt, and a white formal tuxedo vest. She looks at her coifed blonde hair in a handheld mirror, hums softly, and uses a fan to cool down her rising body heat. She lights a cigarette off a candle. She pops her top hat open

and places it on her head with a slightly tilted swagger. She puts on her black tailcoat before tucking in her pocket square, then adjusts her bowtie and strikes a very masculine pose. As a femme queer writer, I cannot help but swoon at this ghost who is so confident in her female masculinity. She is an icon, a vision, and a force of my own identity-making. There is nothing more iconic to the formation of my positionality as a queer woman than looking at Marlene Dietrich's both feminine and masculine embodiment in a tuxedo and feeling that I have permission to exist in ways that challenge expectations of what it means to have female embodiment.

This ghost of Dietrich that I have conjured is made possible by my vivid visual memory, and more specifically by a phenomenon that Bert O. States addresses in his book *Great Reckonings in Little Rooms*: "We do not think of an actor's portrayal of a role as being sealed off in the past tense, but as floating in a past absolute, as if it were, like the role itself, outside time."[6] Marlene Dietrich is always both Dietrich the celebrity/actor and Amy Jolly in *Morocco*. She is always both wearing a tuxedo and a sequined gown. She is always both in the dressing room and on the stage. She is always both buried in a Berlin cemetery and fully present as I write this. As I position Dietrich as being "both," I position her as specifically bisexual, which is to say queer.[7] How is it that this queer cinematic icon is both fixed on stage in her cabaret performances captured on screen and yet accessible to us in 2018? Who and/or what are these haunted echoes of Dietrich's embodiment, and how do they continue to ring?

Indulge me and imagine that our dressing room talk is now taking place after dark. The cast and crew have gone home for the night. I am speaking to you in a half-whisper. We are seated side by side at the dressing room table. Although there is a crack in the mirror, we can still see Marlene Dietrich's ghost, reflected back to us over our shoulders, in her tuxedo, standing by the door smoking a cigarette. There is an odd-sounding creak in the floorboards. We jump. We want to experience the ghost and yet we are afraid of her. Theatres have always been associated with ghosts and hauntings. It is here that I will draw on Marvin Carlson's *The Haunted Stage* to set the tone of this haunted dressing room: "The theatre has been obsessed always with things that return, that appear again tonight, even though this obsession has been manifested in quite different ways in different cultural situations. Everything in the theatre, the bodies, the materials utilized, the language, the space itself, is now and has always been haunted, and that haunting has been an essential part of the theatre's meaning to and reception by its audiences in all times and all places."[8]

Dietrich notices the silence. She puts out her cigarette, opens the door, and looks as if she is about to leave. If she does, should we follow her?

And if so, whom are we following? Marlene Dietrich the celebrity? Amy Jolly the singing cabaret character? Both Dietrich and Jolly? What if I suggest we are chasing more than just Jolly, but Lola Lola the cabaret singer Dietrich portrayed in *The Blue Angel?*[9] Or Helen Faraday—the cabaret singer Dietrich portrayed in *Blonde Venus?*[10] Because isn't there a cumulative effect that occurs with embodiment, almost as if the actor carries all their prior roles in their physical bodies as they move through space? In these films she is returning again and again to similar characters' embodiment.

Before Dietrich even leaves the dressing room space to take the nightclub stage in *Morocco*, whether in 1930 or 2019, there is a residue of Dietrich's other dressing rooms through the cracked yet nostalgic mirrors featured in the Dietrich–Von Sternberg film collaborations. In each of these films, we experience Dietrich's characters having transformative moments where gender and persona change when changing from tuxedo to gown in the dressing room. What is normally a space closed off to the public opens up to allow audiences to peek into a private moment of transformation. In these dressing room scenes we see glimpses of Dietrich's multiple embodiments. For example, one layer is Dietrich the human being—getting dressed at home in preparation to go to the Hollywood film lot to shoot a dressing room scene. We are aware of Dietrich in the context of her celebrity, perhaps remembering the first time Dietrich wore pants to a red carpet event and began to break down traditional gender norms.[11] We are also aware of Amy Jolly the character in the film and her outsider status as someone newly arrived to Morocco from Paris. And we are simultaneously also aware of Amy Jolly's cabaret singer persona in which we see her perform in both tuxedo and in feminine garb. This exciting and voyeuristic dressing room experience allows audiences to participate in Dietrich's embodied moments of transition.

Dietrich's audiences were not only drawn to Dietrich's transformative gendered embodiment; they came to expect this kind of multiple gendered performance from her.[12] Marvin Carlson calls this anticipation of certain kinds of roles "an aura of expectation."[13] Had an audience member seen *The Blue Angel* and then gone to see *Morocco* and/or *Blonde Venus*, even if the plot was different, there would have been immediate recognition by audience members of Dietrich's dual/multiple body. In these films, the fact that Dietrich's embodiment is contextualized in a nightclub—both onstage and off—adds to the Otherness[14] or the queerness of both the dressing room space and Dietrich's embodiment.[15]

In addition to the spatial Otherness that occurs in the three films I have mentioned, all have a central character who is a fallen woman or a femme fatale who turns to performing as a singer in a nightclub to man-

age the constraints of life's circumstances. Feminist film theorist Mary Anne Doane defines the femme fatale as "the figure of a certain discursive unease, a potential epistemological trauma. For her most striking characteristic, perhaps, is the fact that she never really is what she seems to be. She harbors a threat which is not entirely legible, predictable, or manageable."[16] I would like to emphasize that the femme fatale characters have a particular *embodiment* that is in itself a threat. Given the fact that Dietrich is performing femme fatales who also change gender and have queer moments of embodiment, her body becomes even more threatening and less legible/predictable/manageable.

It is fitting to me, then, that the ghost of Dietrich that we have been observing in this queer dressing room essay has been just that: a ghost. Like the femme fatale and the queer body, ghosts threaten. They are never what they seem to be, because aren't ghosts simultaneously dead and alive? Don't ghosts threaten us with reminders of death, of Otherness, of the unknown? Don't ghosts conduct themselves in illegible and threatening ways that escape our control or understanding? To be a ghost of a queer femme fatale is yet another way Dietrich's embodiment is multiple and haunted.

Dietrich's ghost gestures to us to follow as she leaves the dressing room and takes the stage in her film *Morocco*. We must follow her in order to experience what her embodied dressing room transformation has brought about—from Amy Jolly's private street clothes into Amy Jolly's public cabaret tuxedo costume. The premise of *Morocco* is that Amy Jolly is a Parisian singer headed to perform at a nightclub in Morocco. Members at the club are notoriously harsh on new performers. When Dietrich/Jolly—double-name intentional as a reminder of her multiple embodiments—takes the stage decked out in a black tuxedo, the audience erupts in impolite jeers. She does not react to their hostility, but instead leans coolly on the arm of a chair. A young and handsome legionnaire named Tom, played by Gary Cooper, is instantly enamored. He shouts for those booing to stop. Dietrich/Jolly makes intense eye contact with him as she blows her cigarette smoke in his direction. Tom goes so far as to put his hands on the neck of a Spanish woman he is sitting next to at the show to get her to stop booing. Tom is experiencing Dietrich/Jolly's Othered beauty in a decidedly affective way. I know how you feel, Gary Cooper.

Dietrich/Jolly then saunters over to a rail and leans on one hip, with one leg dangling. She sings "Quand l'amour meurt" (When Love Dies) in French, which, in addition to her masculine dress, adds another layer to her Otherness. We have only heard Dietrich speaking in English with a German accent; now we learn that she contains multiple languages. People fan themselves from the heat while they listen to her sing. Gary

Cooper beams while the Spanish woman he sits with scowls. Dietrich/Jolly's confidence never wavers in the song. She knocks her hat back casually with her wrist so the audience can see more of her face, then tips it back down at the end of the verse with masculine verve. She has won them over.

Now we get to the exciting and explicitly queer material that got me started on this journey to begin with. A man in the crowd offers Dietrich/Jolly his champagne. She drops her cigarette to the floor, swings her leg over the rail, and hops over with a masculine swagger. She takes the glass, makes a small toast, drinks it all in a masculine chug, then looks at the woman sitting with the man, looks to the man, then back to the woman as the woman giggles. Dietrich/Jolly looks away from the couple at the table for a few more seconds, then deliberately looks back to the woman in an explicitly queer act of flirtation. Dietrich/Jolly steps in, takes the flower out from behind the woman's ear, and says, "May I have this?" "Of course," the woman replies. Dietrich/Jolly sniffs the flower sensually before tilting the woman's face up and kissing her on the lips. The woman giggles and hides behind her fan. Everyone is clapping and happy about it, including the woman's husband. Dietrich/Jolly flicks her top hat up with her fingernail in her signature style. Then she moves away from the table and takes her hat off to bow to the crowd that is still clapping and laughing. She sniffs the flower and saunters back toward the stage. On her way, she takes one last sniff of the flower before tossing it to the very enamored Gary Cooper/Tom character who is now standing on his feet for her.

There are both Dietrich the actress and Jolly the character, both the male and female body present in Dietrich/Jolly's tuxedo costume, both same sex and opposite sex attraction between her and the giggling kissed woman and Gary Cooper. From there we can subdivide Dietrich's haunted embodiment into even smaller increments when thinking of: Dietrich's celebrity, her reported bisexuality, and the fact she left her husband and child in Germany to go to Hollywood in what her fans perceived to be an authentic fallen woman or femme fatale plot. This affective residue and ghosting only thicken as the story moves along.

In the next dressing room transformation, Jolly changes into a black velvet bathing suit complete with rhinestone belt and a giant feather boa wrapped around her shoulders. She has gone from having her arms and legs fully covered to revealing a great deal of skin. Her embodied demeanor has changed along with her garment. She's gone from standing confidently in her tuxedo to moving in anxious and more vulnerable patterns in the bathing suit costume. During this transformation, she is visited by a wealthy male suitor whom she met coming over on the boat

from France. With Dietrich dressed in a feminine outfit, the male suitor is allowed to occupy her dressing room space in a different way, that of a consumer with specific demands on her attention despite the fact she is trying to get back onto the stage. When she makes her way back onto the stage to sing her next song, she sings in English—which would have been the expected and more legible language to film audiences of the time. The song evokes the archetypal Eve from Genesis as she sings: "What Am I Bid for My Apple?" Her objective is not only to sing, but also to sell the apples in the basket to the audience in exchange for money. In this moment, Dietrich/Jolly reads as female, in female drag, due to the fact that, having worn a tuxedo in the scene prior, her body retains a ghosted queer embodiment that visually reads both male and female *and* neither male nor female.

There is an element of Dietrich/Jolly having less agency while performing in this new iteration of her gender embodiment. She is sent to sell apples and close these sales while singing, whereas in her tuxedo her entire purpose was to entertain without vending wares. A man in the audience grabs her feather boa and there is a pause where the music stops. Dietrich/Jolly pulls it away from him. Now she's collecting money and trying to smile. She goes to the officer's table where her wealthy suitor gives her a large bill and she says she doesn't have change. He tells her to keep it. "You are again very kind." He asks to see her later and she says, "Some other time, perhaps." The bold manner in which Dietrich flirted with a woman while wearing a tuxedo to enrich her masculinity, followed by her proposition of a man while wearing hyper-feminine garb to increase her femininity, allows Dietrich's queer theatrical embodiment to take on a new layer of unpredictability. She is haunted by both masculine and feminine, queer and normative qualities, the echoes of her multiplicity ringing in the air.

Dietrich/Jolly saunters to Gary Cooper/Tom, who sits with the legionnaires who have little money and are of a different social class. He thanks her for the flower. "Can I offer you an apple too?" she says. He asks his friend to borrow two weeks' pay, which is the price of the apple. She replies, "You can have it for nothing if you like." "Nothing doing. I always pay for what I get." She takes his money, gives him an apple, and he takes a bite. "I'd sit down if I were you," he says in a confident tone. She sits tentatively and then quickly stands. "You are pretty brave with women." "What's the matter you—don't like brave men?" "Perhaps." She slips something to him as he chews the apple watching her. The camera zooms in and we see she has slipped him a room key. He smiles and chews.

There is an important intertextuality between these two songs and the

juxtaposition of the tuxedo/feminine dress. Without the tuxedo's initial semiotic framing of Dietrich's body as masculine and strong, the revealing feminine outfit would contain far less meaning when she takes the stage the second time to sell her apples. As the tuxedo-wearing Amy Jolly she can kiss a woman, but she could not give Gary Cooper's character a key to her room. As the feminine, velvet swimsuit-wearing Amy Jolly, she is free to entice a man to join her at her apartment. This is the crux of Dietrich's queer haunted embodiment: Dietrich the actor, Jolly the character, Dietrich the celebrity who was romantically linked with director von Sternberg, Dietrich/Jolly as a woman who kisses women, Dietrich/Jolly who gives her hotel key to a handsome young man, and the residue of cabaret performance of Dietrich as Lola Lola from *The Blue Angel* (which came before this film). This is beyond the dual; this nightclub overflows with a multiple, queer hauntedness made possible through the transformational magic of the dressing room space itself.

I am not the only person who wants to occupy Marlene Dietrich's dressing room or spend time contemplating her embodiment. Madonna has consistently evoked certain elements of Dietrich's iconic looks throughout her career in ways that have read as queer fashioning to the queer community. In a staged photograph done by Matthew Rolston in 1986, Madonna sits at a dressing table wearing a nearly identical suit to Dietrich in *Morocco*. Above the table a dressing room mirror bears the same heart-breaking lettering that Gary Cooper's legionnaire character leaves on Dietrich's dressing room mirror: "I changed my mind. Good luck!" And whether it's Madonna evoking Dietrich through androgynous menswear in photographs or kissing Britney Spears at the MTV Music Awards, as Dietrich kissed a woman on screen in *Morocco*, or whether it's drag performer Sasha Velour doing a Marlene Dietrich number on season 9 of *RuPaul's Drag Race*, the moments where Dietrich's embodiment lives on in other queer bodies are other examples of ways in which conjuring ghosts of queer past can open up queer futures.

Joseph Roach wrote in *Cities of the Dead*: "Even in death actors' roles tend to stay with them. They gather in the memory of audiences, like ghosts."[17] Marlene Dietrich's embodiment, specifically when in a tuxedo, is always gathered close to me. By conjuring her ghost in this essay, I am able to give my own body permission to exist. When I kiss someone who is both masculine and female-identified, I can sometimes hear the echoes of Dietrich humming in her dressing room or the quick sound her fingernail makes popping up her top hat. And though I hate to let Dietrich out of my sight, even for a moment, I must now turn off the lights and escort you out of the dressing room. My hope is that in conjuring the performative ghosts of women like Marlene Dietrich and "feeling backward"

to create queer futurity, I will not only contribute to a scholarly conversation in which queer space and queer futures exist, but one in which they are readily accessible to all those who seek them.

Notes

1. For three examples of foundational scholars working in the intersection of embodiment and feminist film theory, see Teresa De Lauretis, Mary Ann Doane, and Patrice Petro.

2. *Morocco*, directed by Josef von Sternberg, 1930 (Universal City, CA: MCA Universal Home Video, DVD).

3. Marvin Carlson, *The Haunted Stage: The Theatre as Memory Machine* (Ann Arbor: University of Michigan Press, 2001).

4. See Diana Taylor, *The Archive and the Repertoire: Performing Cultural Memory in the Americas* (Durham, NC: Duke University Press, 2003).

5. For further discussion of affect theory to create queer historiography, see Heather Love's book *Feeling Backward* (Cambridge, MA: Harvard University Press, 2009).

6. Bert O. States, *Great Reckonings in Little Rooms: On the Phenomenology of Theater* (Berkeley: University of California Press, 1985), 200.

7. For discussion about bisexuality and queer identity in this context, see the work of Marjorie Garber, especially *Vice Versa: Bisexuality and the Eroticism of Everyday Life* (New York: Simon & Schuster, 1995).

8. Carlson, *The Haunted Stage*, 15.

9. *Blue Angel*, directed by Josef von Sternberg, 1930 (New York: Kino Lorber, DVD).

10. *Blonde Venus*, directed by Josef von Sternberg, 1932 (Universal City, CA: Universal Studios, DVD).

11. For more information about the first time Dietrich wore pants on a red carpet, see Laura Horak, *Girls Will Be Boys: Cross-Dressed Women, Lesbians, and American Cinema, 1908–1934* (New Brunswick, NJ: Rutgers University Press, 2016).

12. Horak writes about this horizon of expectation in *Girls Will Be Boys*.

13. Carlson, *The Haunted Stage*, 59.

14. See Homi Bhabha, "The Other Question: Stereotype, Discrimination and the Discourse of Colonialism," *Screen* 24, no.1 (1983): 18–36.

15. For further reading on the physical cabaret space as an intimate and Othered space, see Shane Vogel, *The Scene of Harlem Cabaret: Race, Sexuality, Performance* (Chicago: University of Chicago Press, 2009).

16. Mary Ann Doane, *Femmes Fatales: Feminism, Film Theory, Psychoanalysis* (New York: Routledge, 1991), 1.

17. Joseph Roach, *Cities of the Dead: Circum-Atlantic Performance* (New York: Columbia University Press, 1996), 78.

Contributors

Cohen Ambrose is an actor, director, teacher, playwright, dramaturg, and scholar who has lived and worked in Montana, Washington, New York City, Maryland, and Prague, Czech Republic. He holds an MA in Performance Theory and Criticism and an MFA in directing from the University of Montana. His research and scholarship interests include Brecht, Meyerhold, Chekhov, actor-training, phenomenology, pragmatism, media and digital dramaturgy, and cognitive science in performance. His work has been published in *Theatre Symposium*, *Wheelhouse Magazine*, *State of the Arts*, *The Brecht Yearbook*, and by the University of Montana Press. He has directed and/or acted in over twenty professional and academic productions. He teaches acting, script analysis, philosophy, and theatre history at the Community College of Baltimore County.

Rhonda Blair is a professor of theatre at Southern Methodist University. Representative publications include *Theatre, Performance and Cognition: Languages, Bodies and Ecologies* (co-edited with Amy Cook); *The Actor, Image, and Action: Acting and Cognitive Neuroscience*; editing Boleslavsky's *Acting: The First Six Lessons*; articles in *Affective Performance and Cognitive Science*; *Routledge Companion to Stanislavsky*; *Routledge Companion to Theatre, Performance, and Cognitive Science*; and in the *Journal of Dramatic Theory and Criticism*, *Theatre Survey*, *TDR*, and *Theatre Topics*. She is a board member for the Centre for Kinesthetics, Cognition, and Performance and has delivered keynote and featured talks on theatre and cognitive science in Paris, Rome, Kent, Wroclaw, and Zurich, among other places. She directs and creates performance pieces. She is a past president (2009–2012) of the American Society for Theatre Research.

Tessa W. Carr is the artistic director of the Mosaic Theatre Company and an associate professor of theatre at Auburn University. Her creative scholarship focuses on applied theatre as a means of creating civic dialogue and social change, and feminist performance strategies and practices. As the artistic director of Mosaic Theatre Company, she facilitates the devising of performance pieces that engage issues of diversity, inclusion, and social justice. The mission of the company is to foster dialogue in the community. Her work has been published in *liminalities*, *Theatre Topics*, *Text and Performance Quarterly*, and *Southern Theatre* magazine.

Kaja Amado Dunn is an assistant professor of theatre and the head of the acting program at UNC Charlotte, as well as an actor, director, and teacher. She has presented her work on training theatre students of color at University of London Goldsmiths, SETC and SETC Theatre Symposium, KCATF, and the Association of Theatre in Higher Education, among other places. She is on the National Board of the Black Theatre Association. She has performed in over forty shows and taught internationally. She was a 2018 keynote panelist at NCTC. Kaja was previously a lecturer at California State University San Marcos and toured with Ya Tong Theatre in Taiwan. Other teaching credits include working with homeless and foster youth with Playwrights Project San Diego and as a teaching artist with Young Audiences. Her primary research focus is on using theatre to facilitate complex cultural conversation and reimagining theatre training for actors of color. She frequently posts on Twitter about EDI issues under the handle @ KajaDunn.

Andrew Gibb, *Theatre Symposium* associate editor, is the area head of history, theory, and criticism in the School of Theatre and Dance at Texas Tech University. He has published work in *Theatre Symposium*, *Theatre History Studies*, the *Latin American Theatre Review*, and the *Texas Theatre Journal*, and has presented at Theatre Symposium, ASTR, ATHE and the International Conference on Chicano Literature. Andy is pleased to begin his term as *Theatre Symposium* editor with the upcoming *Volume 28: Theatre and Citizenship*.

Sarah McCarroll, *Theatre Symposium* editor, is an associate professor of theatre at Georgia Southern University, where she is also the resident costume designer and costume shop manager. Sarah's research interests include period dress and movement, the historical body, and British theatre of the late nineteenth century. Her work has appeared in *Theatre Symposium* and in *Theatre, Performance and Cognition: Languages, Bodies and Ecologies*. Sarah's PhD is from Indiana University and her MFA

is from the University of Alabama. She is currently in the early stages of a monograph theorizing stage costume and its relationship to the body. Sarah's professional work includes Utah Shakespeare Festival and Milwaukee Repertory Theatre.

Timothy Pyles is an assistant professor of acting and head of the acting program at the University of South Dakota. He received his MFA in acting from Southern Methodist University and his PhD from Indiana University. Tim's recent work can be read in *Philosophy and Literature*. Tim is currently working on his first book—a study of supernaturalism in Shakespeare as it relates to early modern religious and political controversies. Tim is a proud member of the Actor's Equity Association and has appeared professionally at theatres including the Utah Shakespeare Festival and the Black Hills Playhouse.

Lawrence D. Smith is an assistant professor in the Department of Theatre Arts and Dance at the University of Arkansas at Little Rock and a professional actor. He received his PhD from the University of Illinois at Urbana-Champaign. His scholarship bridges theatre history, cinema studies, and performance theory and has been published in *Nineteenth Century Theatre and Film*, *Theatre Symposium*, and *Journal of Scandinavian-Canadian Studies*. He has made presentations at conferences including ASTR, ATHE, Theatre Symposium, MATC, and the Society for the Advancement of Scandinavian Study. He teaches theatre history, dramatic criticism, African American theatre, and acting. He is currently working on a cultural history of *Miss Julie*.

Travis Stern is an assistant professor in the department of Theatre Arts at Bradley University, where he teaches theatre history, dramatic analysis, and the creative process. He earned his PhD in theatre from the University of Illinois at Urbana-Champaign. He has presented his work at ASTR, ATHE, MATC, and the Cooperstown Symposium on Baseball and American Culture. His current research focus includes the intersections of baseball and theatre as well as the history and theory of improvisation and comedy.

Bridget Sundin is a PhD candidate in theatre history, theory, and dramatic literature with a minor in gender studies at Indiana University. Her research interests include embodiment, feminist theory, and queer theory/queer futurity. Bridget's dissertation project uses those theories to examine Josephine Baker and Marlene Dietrich's performances of gender on stage and screen.